To grampa
Meery Christmas
Love Donna
&
Bob
"2007"

M000107376

IMAGES
of America

LISBON

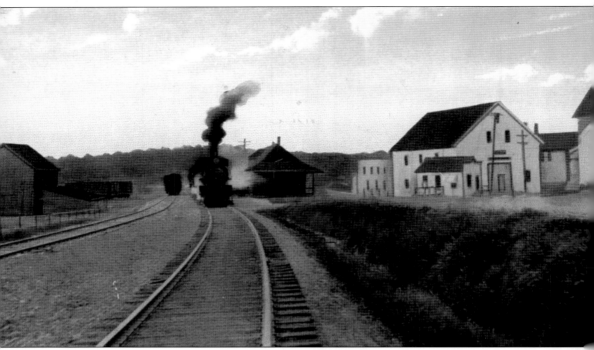

This late-1800s postcard depicts the Androscoggin Railroad, a branch of the Maine Central Railroad. Established in 1851, the rails connected Lisbon to Lewiston and Brunswick, offering transportation for citizens and products. The depot on the right, built around 1910, was a hub for downtown activity, helping Lisbon to prosper. (Ken and Arlene Harris.)

On the cover: This 1880 photograph of the Lisbon Bicycle Club was taken in "the Grove," near the Worumbo Mill entrance. These Spinner-brand bicycles were manufactured in Lisbon, where they were used for transportation, as well as recreation. Members shown, from left to right, are Herbert Doten, Will Sawyer, George Turgeon, Del Hanson, Gabe Goldstein, Reinhart Kneipfe, and Alvis Lange. (Lisbon Historical Society.)

IMAGES
of America

LISBON

Debra Colleen Daggett

ARCADIA
PUBLISHING

Copyright © 2006 by Debra Colleen Daggett
ISBN 0-7385-3914-7

Published by Arcadia Publishing
Charleston SC, Chicago IL, Portsmouth NH, San Francisco CA

Printed in the United States of America

Library of Congress Catalog Card Number: 2005930997

For all general information contact Arcadia Publishing at:
Telephone 843-853-2070
Fax 843-853-0044
E-mail sales@arcadiapublishing.com
For customer service and orders:
Toll-Free 1-888-313-2665

Visit us on the Internet at www.arcadiapublishing.com

CONTENTS

With great love and respect, I dedicate this book to my sister and best friend, Bonny, with whom I had the extreme pleasure of sharing many unforgettable adventures, growing up together in Lisbon. With daughters' hearts, Bonny and I celebrate childhood memories made in Lisbon, honoring our father, our hero, for all the things that matter most. With love, this book is for him.

ACKNOWLEDGMENTS

My heartfelt appreciation is extended to Dorothy Smith, beloved curator of the Lisbon Historical Society. Dot's energy, enthusiasm, and genuine love for this town and its people has made the historical society the comprehensive resource that it is. Without her tireless investigation of photographs and research of facts, this book would not exist. Dot's total dedication is truly one of Lisbon's greatest present-day treasures.

Supporting the Lisbon Historical Society as its president and caretaker is Alfred Smith. His devotion to the preservation of the town's memorabilia keeps the interest alive. Al was always patient and extremely helpful in putting this collection together.

Many of the wonderful photographs in this book began as early-20th-century negatives, property of Linda Gamrat of Lisbon. The flavor of the manuscript would be vastly different if not for these beautiful images. Linda volunteers with the Lisbon Historical Society and selflessly shares everything she has for public enrichment.

Bill Barr, proud owner of the oldest house in Lisbon Falls, is a relentless investigator for the historical society. A regular volunteer, history buff, and patriotic advocate, Bill's enthusiasm for Lisbon is equaled only by his friendly personality. He certainly added lots of fun to this project.

Lisbon Historical Society member and longtime volunteer Thomas "Tommy" Huston loves to tell stories of Lisbon. His memories of the citizens and the history of the town were invaluable to this book. It was great fun to look at Lisbon through his eyes.

To Merton Ricker, a walking encyclopedia of Lisbon, I give great thanks for his glorious pictures and unique insight.

Marc Stevens, recreation director, came to the technological rescue of this project by lending computer projection equipment for picture identification purposes. On more than one occasion, his support and expertise saved the day.

I want to thank the fire departments and the public library for kindly sharing their superb photographs.

The writing of this book offered me excellent opportunities to meet new folks and talk with others that I had not seen in years; that is truly the part of this endeavor that I will cherish forever. Some of those contributors to this book include Donna Pelkey, Harrison and Doreen Wakely, George Huston, Faye Brown, Walter and Blanche Parker, James Fournier, Alfred Galgovitch, John Shaughnessy, Ken and Arlene Harris, David Hale, Charles Plummer, Forest and Linda Jordan, Joe Fillion, Alfred Galgovitch, Janet Cameron, Donna Neagle, Madeline Junkins, and Patricia Peterson. Norm Fournier, cocreator of the historical society, offered photographs and his expansive knowledge to the project.

With all of my heart, I treasure the support of my family. Thank you to my wonderful in-laws Bea and Willard Daggett for always caring, and helping in so many ways. My parents Paul and Claire Black were always only a telephone call away, ready to help in any and every way possible. With special love to Claire, who treats us like her own—and wears an invisible halo, I thank you. My cousins Barry Wheeler and Carol Edwards spent hours looking over photographs and sharing stories and facts. I thank my sisters Bonny Hartnett, Carol Levesque, Karen Smith, and Louann Bisson for their ongoing encouragement and enthusiasm, as well as my aunt Christine Jellison for her vast knowledge of people and places around town. I adore my sons, Corey and Mike for their humor, their interest, and their good-natured nudging when I needed it. In addition, I feel great love and appreciation to my husband, Steve, for his total acceptance, unbelievable patience, and complete commitment to helping make this book a reality.

Everyone can use a cheerleader during a project like this one and Dawn Robertson, editor for Arcadia Publishing, has been my anchor. From day one, she has shown constant enthusiasm, saintly patience, intelligent guidance, and faithful commitment to this book. Unflappable, Dawn has advocated tirelessly for this publication and has worked above and beyond throughout every aspect of the editing process. Her impeccable taste and exquisite eye gives the book its character. Always on call, Dawn has been a constant collaborator, and I have come to rely upon her expertise and value her friendship. I know for certain that this book exists because of Dawn; I am deeply grateful for her persistence.

This final acknowledgment is extended to the people of Lisbon. It is not the river, the landscape, nor the buildings that make the town of Lisbon special. It is the people. I acknowledge your contributions and that of your ancestors—and I thank you for sharing your memories. More than anything, I urge you to listen to the stories of your family and to retell them whenever possible. Save your photographs—write notations on them—and please share them with your historical society, for celebration and preservation of your important personal history. Thank you for making Lisbon great. Many blessings to each of you.

INTRODUCTION

In celebration of the fascinating history of Lisbon, Maine, this photographic chronicle introduces you to the three-village community, known as the gem of Androscoggin County. At 24 square miles, this welcoming land, first known as Thompsonborough, is bounded by, supported by, and occasionally plagued by the powerful Androscoggin River. One of the Lisbon villages took its name from the river. Known first as Little River, then as Ten Miles Falls, it is Lisbon Falls today. Lisbon Village and Lisbon Center completed the picturesque community as a perfect place to settle in the 17th century. Sharing a legacy of work, family, faith, pride, and optimism, Lisbon is still one of the best locations in Maine today.

Centrally located in Maine's interior, Lisbon boasts every early advantage. The Androscoggin, with its tributaries, was the key to survival of early Lisbon homesteaders. Water provided the essential power to six sawmills established at the beginning of the 19th century. Lisbon was thriving with a population of 450 citizens. Milling lumber enabled industrious workers to nurture their families, while providing building materials for a multitude of purposes. Fishing and hunting were plentiful sources of nourishment, and immigrants were free to preserve the faithful doctrines they carried to this new home. Sharing these principles was fundamental to the success of Lisbon as a community.

During the spring of 1814, as if in a test of strength, the river displayed its forceful prowess over the sawmills, sweeping away the town's vital economy in a mighty flood. Undaunted, the collective enterprising spirit rose above the flood, returning with an entrepreneurial vengeance as Lisbon flourished into the century. Lisbon's population had grown to 1,100 in 1840 and had more than tripled that census by 1900. Woolen and cotton mills, including the Worumbo, Farwell, and Farnsworth, were the area's largest employers and most widely recognized names in manufacturing excellence. The skill and quality of workmanship of the factories' talented employees had earned Lisbon the top spot on a competitive global textile map. Paper and paint manufacturers joined the industrial revolution of the town.

As employment grew, the quality of life expanded for the hearty townspeople. Buoyed by transportation needs, a trolley system and a railroad connected towns to the east and the west. Neighborhoods were established, and social and civic groups were organized. Mills changed hands, a newspaper was born, and townspeople weathered every storm with the determination of their predecessors. On April 6, 1901, a devastating fire ripped through downtown Lisbon Falls, taking 31 buildings to rubble, leaving 50 families homeless and countless businesses in ruin. The citizens rallied, rebuilding downtown shops of mortar and brick. Most of those buildings are still visible and viable today. In 1936, the second-largest flood surged through town, carrying with

it the iron bridge, once connecting Lisbon to Durham. Cleanup was as swift as the river, and a stronger steel bridge still stands in its place. Through the years, there were great triumphs and temporary tragedies, but mostly there were the people, living one day at a time, building their futures in Lisbon, just as those before them had built their town.

The folks of Lisbon worked well together—and the more they worked, the harder they played. The evolution of downtown gave welcome to movie theaters, groceries, millinery shops, pool halls, and ice-cream parlors. From horse races and ice-skating on frozen water to fishing and canoeing, the river was a vital site for recreation. Sports teams, organized through school and public arenas, offered many opportunities for friendly rivalries to form, honest competition to flourish, and even more reasons to celebrate as a community. Regardless of the sport, from baseball to bowling, Lisbon seemed to prevail. Marching bands, always at the ready, led magnificent parades. Festivals, picnics, and concerts, planned months in advance, were community events. Politics, often heated, was a venue for public debate; the town meeting was born and nurtured into present time. Schools and churches were established, and it was upon the acceptance of each other's customs and beliefs that Lisbon's strong foundation was built. Holding fast and true to religious freedom, churches were some of the first public buildings in Lisbon, with innumerable denominations represented respectfully throughout town. Civic organizations followed suit.

Perhaps the town's vitality can be attributed to the spicy blend of cultures, incorporated into the finest mix of townspeople. Added to that is a dash of Maine pride, a sprinkle of down east humor, a handful of hardship, gobs of courage, and unlimited ingenuity. The "good ole Maine work ethic" is penned as often as is "Yankee spirit." Somehow it seems as though those phrases were first coined in Lisbon. All of these attributes, when blended together with ethnic pride and American patriotism, became the foolproof recipe for Lisbon.

From Thomas Purchase, Lisbon's first documented settler in 1628, to the nearly 10,000 citizens of today, this area's legacy has been its people. Migrating from European homelands, brave and hearty persons of varied and colorful backgrounds made Lisbon their homes. Faithful to their origins, French, German, Slovak, English, Italian, and Irish families found Lisbon to be a haven for worship, work, friendship, and family. With celebrations aplenty, Lisbon's immigrants lived a good life. No strangers to adversity, their iron wills prevailed and the legacies of Lisbon's earliest settlers live on in their ancestors today. Pictured in this book are historic photographs that honor the people of Lisbon, documenting the community's significant heritage. The fabric of Lisbon's history is as intricately woven as Worumbo cloth. Memories are captured in the faces and places celebrated in this book. Some facts may be found to be in error; for that I apologize in advance. What I hope is portrayed poignantly is the indomitable spirit of a town, which is of course its people, the things they care about, and the things they created. Lisbon is a puzzle, with every piece a person and every person important to the final picture. Not every individual in historic Lisbon is pictured here. However, every single man, woman, and child that went into the heart and soul of this town is respectfully represented here. It is for each of you that this book, simply entitled *Lisbon*, is published. We celebrate you, your families, and your town.

One

RECREATION AND
CELEBRATION

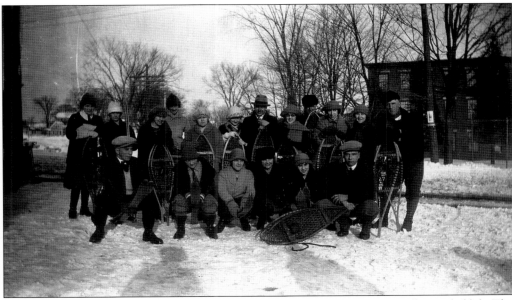

In Lisbon, personal interests are encouraged and supported as a means to a well-rounded life. The natural habitat of the town supports fishing, hunting, canoeing, ice-skating, skiing, sledding, and snowshoeing. The old swimming hole was more than a romantic notion; it was a rite of passage for all honest-to-goodness kids at the beginning of the 20th century. Croquet, archery, darts, bowling, pool, checkers, and marbles are buddy activities, and there always seemed to be a friend when needed. There were barnstorming planes, horse races on the river, and firemen musters for those who craved excitement; quilting clubs, movie theaters, and picnics were available when one just wanted to relax.

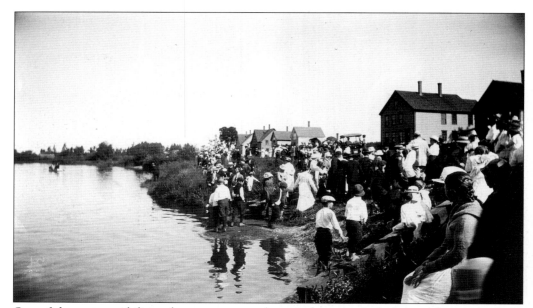

One of the greatest abilities that a person can have is the aptitude for having fun. As a whole, the people of the town of Lisbon have the market cornered on enjoying life. While there are not many folks who have a greater history of hard work than Lisbon folks, when it comes to recreation, residents of the Lisbon community take the gold.

Happily, there are as many ways to celebrate life as there are personalities in the town. Whether it is team competition, personal goals, or just-for-pleasure outings, there is something for everyone. From the earliest settlers, leisure time was valuable time. Ethnic organizations, including Slovak, French, Greek, German, and English, had traditions of dances, public suppers, and theatrical presentations. Saturday night was always a big time on the dance floor with music performed by talented club members.

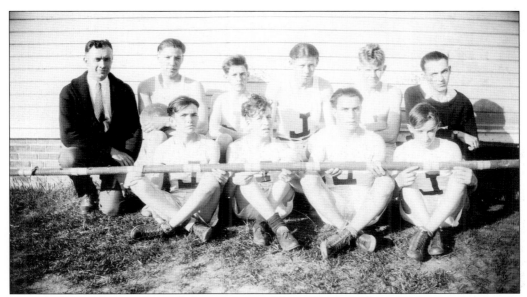

Organized sports have traditionally been a source of fun and pride. Perhaps there is something in the river, for the relatively small town of Lisbon certainly has had more than its share of talented sports enthusiasts. From fielding a semi-professional baseball team, with members making it to the big leagues, to winning championships for the schools, Lisbon has had a history of sporting success.

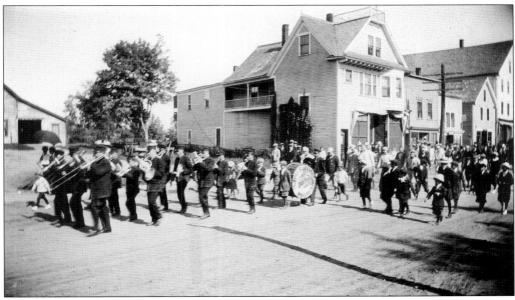

Parades and public celebrations are family affairs, and no one does it better than Lisbon. It seems that every holiday calls for a parade, and Lisbon always pulls out all the stops. No parade has been complete without each of the civic organizations involved, as well as religious groups, fire and police departments, wagons and Model As, children in and out of costume, and honored servicemen and servicewomen. (Linda Gamrat.)

This photograph of an early-1900s parade, marching down Lisbon Road in front of the Farwell Mill, features an intriguing vehicle pulling a float sporting a three-man band, carrying a drummer, an accordion player, and a third gentleman. The two men seated on the outside of the vehicle seem to be displaying signs and must have traveled through the entire parade with their heads through the signs. According to one car expert, the vehicle was not customized; the unique car was most likely manufactured with the curved windows in the back. (Linda Gamrat.)

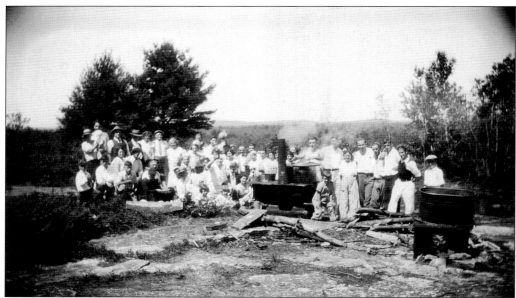

When looking at the people in this town, one of the first observations is that Lisbon folks know how to live. Yes, they work hard. Just as importantly, Lisbon plays hard—making it one of the finest towns in which to live. Pictured here is an old-fashioned Maine clambake around 1910. (Linda Gamrat.)

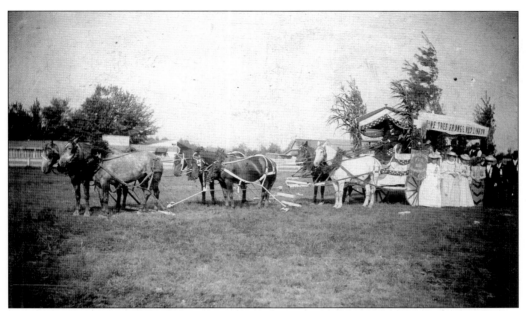

Pictured at the September 1895 Maine State Fair is the horse-drawn Pine Tree Grange No. 3 Patrons of Husbandry float from Lisbon. (Lisbon Historical Society.)

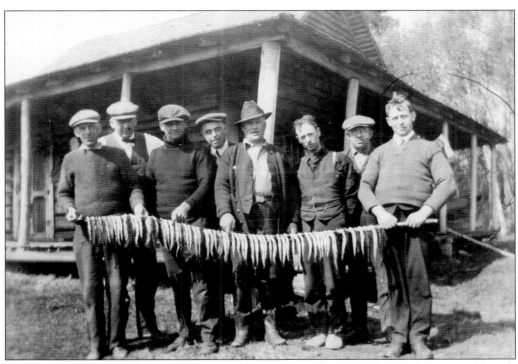

With its many rivers and streams, Lisbon is an excellent place to go fishing. A group of friends had a very successful catch. Shown here are A. Carter, Mr. Dodge, Frank Whittier, Doc Gerrish, Fred Hall, Charlie Coolidge, and a Mr. Foster. (Lisbon Historical Society.)

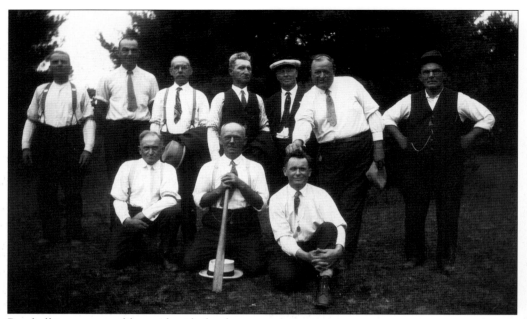

Baseball is a source of fun and pride for the town.

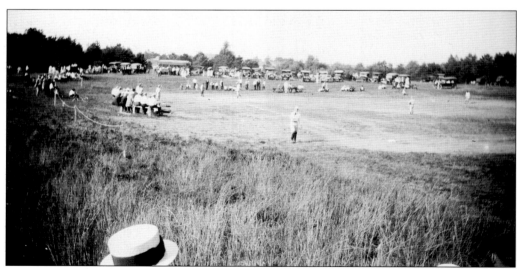

Men's baseball was extremely popular in Lisbon in the early 1900s. This game took place at the trotting park (named because farmers trotted their horses here) in Percy Plummer's field in Lisbon. Class picnics were also held here. Eventually the men even managed to secure an official scoreboard for their games. (Linda Gamrat.)

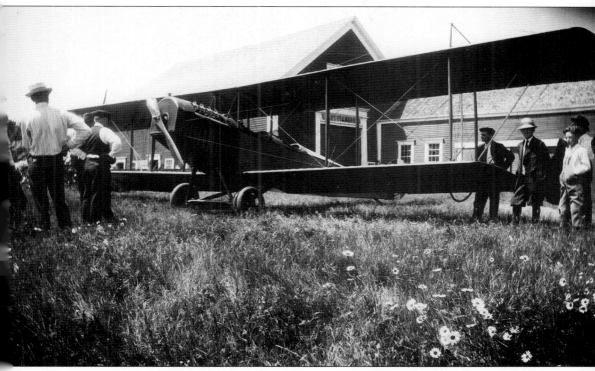

There are many great stories surrounding the men of Lisbon and their flying machines. Shown here is a double winger with open cockpit and two seats. The wide-open spaces and vast fields of the early 1900s provided perfect opportunities for take-offs and landings—and a bit of showmanship in between. There was said to be an actual airport for these planes at the bottom of Frost Hill in the Falls. While there were a number of planes and barnstorming pilots that captivated observers on the ground, the name Walter "Mosey" Moore is often heard in conjunction with fearless stunts and airborne antics. Mosey would land his aircraft on the ground and in the river, taking on adventuresome passengers at whim. If he was flying about and he buzzed a home, they knew he was ready to give them a ride. From flying upside down through open-ended barns, taking the tops off of trees, to swooping down to let a passenger jump into the river for a swim, Mosey was daredevil pilot extraordinaire. (Linda Gamrat.)

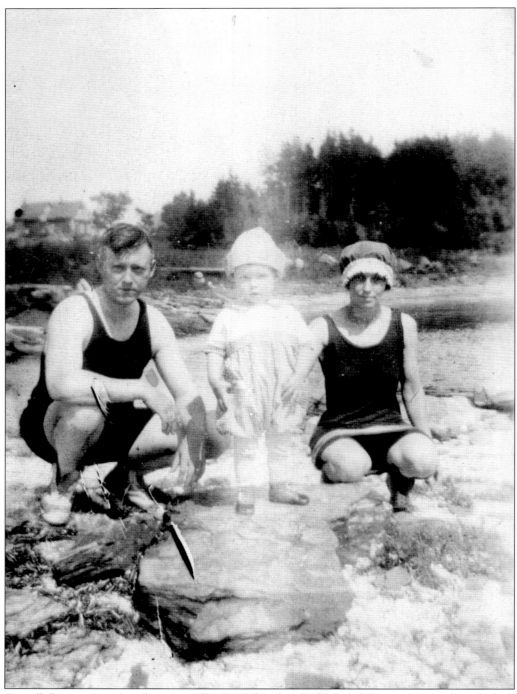

Carroll (businessman) and Louise Wheeler (schoolteacher) enjoy a day at the beach with their son, Walter, born on January 2, 1924. (Barry Wheeler.)

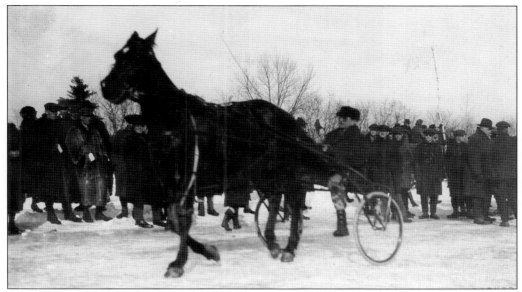

Roy Goodwin is shown at the reins of his sulky at the Lisbon horse races held annually in the early 1900s on the frozen Androscoggin River. Hundreds of race fans turned out to hear the roar of the hooves, caused by caulks screwed into the horses' shoes for traction. To the author's knowledge, no horse ever fell while running those races. Tragedy marred the races one year when a truck belonging to Wilbur "Dubba" Taylor went through the ice. Taylor was pulled to safety, but his passenger, Stubby White, drowned. (George Huston.)

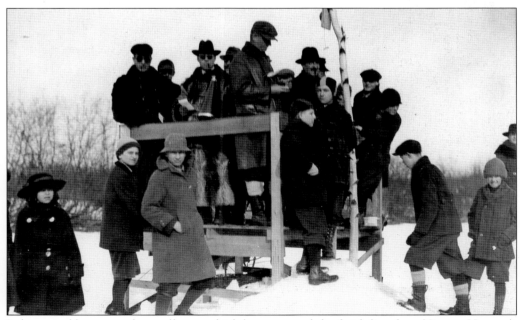

Judges stood here to make a call as to which horse crossed the finish line first. (George Huston.)

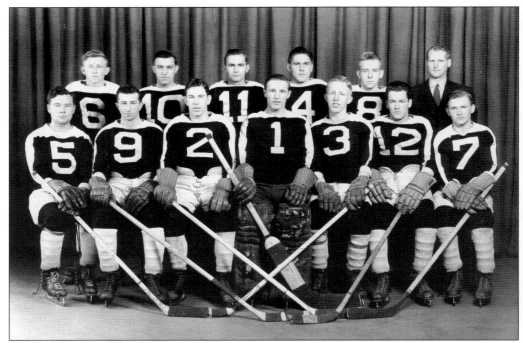

The Lisbon Hockey Team is pictured here. From left to right are (first row) George Krochune, John Csorosz, Willis Allen, Donald Karkos, Clifford Warren, Stan Dixon, and Edward Prosser; (second row) Bernard Popadak, Mike Marchak, Russell Winn, Frank Karkos, Phil Sugg, and Winn Gillis. (Lisbon Historical Society.)

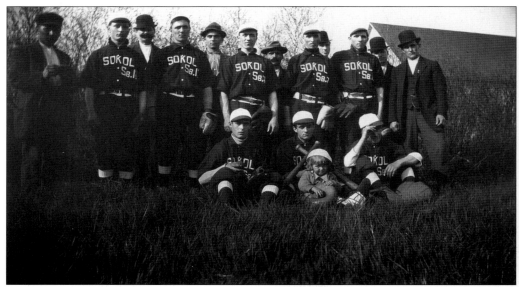

Sokol baseball was a Slovak team in Lisbon. The only player currently identified is John Ivanson.

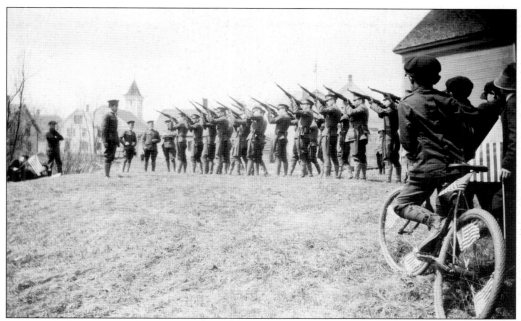

Pictured is a military ceremony, perhaps on Memorial Day, with what looks like a 16-gun salute. Note the unique rear-wheel drive on the boy's bicycle. (Linda Gamrat.)

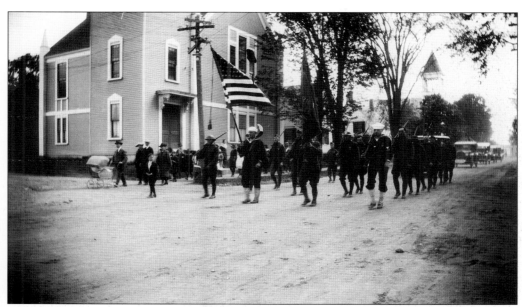

Men from many branches of the military lead this parade, which stretches all the way down Main Street in Lisbon Village. The servicemen are pictured in front of the Methodist church. Four doors down is St. Anne's Catholic Church. (Linda Gamrat.)

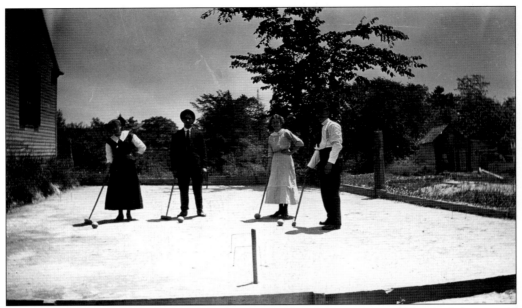

This photograph shows a 1920s game of croquet, using a croquet court. The English game of croquet made its way to America, by way of Hawaii, in 1853. Former slave Frederick Douglass played the game, fell in love with it, and built a croquet court at his Virginia home in 1894. The fascination for the game spread throughout the country, becoming a family pastime, as well as a competitive sport.

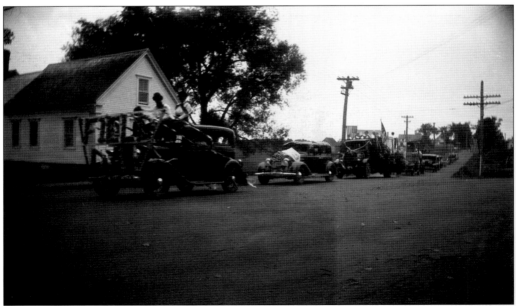

A parade travels down Ferry Road and onto Main Street in Lisbon as part of a Fireman's Muster and celebration. The lead car is passing the home of Erlon Daigle. Looking closely, one can see the words Field Day attached to the vehicle. (Linda Gamrat.)

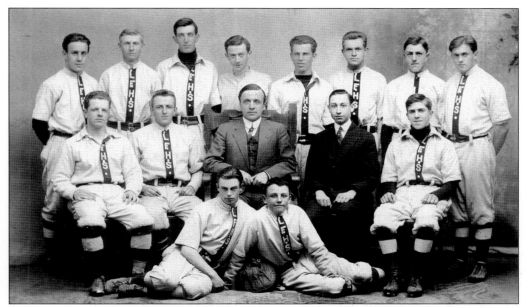

Shown is the Lisbon Falls High School's champion baseball team of 1915–1916. Pictured from left to right are (first row) Edward Prosser and Stetson Plummer; (second row) Fred Hall Jr., Frank Stone, principal Nelson Mixer, team manager Arthur Demuth, and Alfred White; (third row) George Littlefield, Carlyle Goddard, Willis Philbrook, Walter Lange, Carl Bailey, Leon Huston, Francis Plummer, and Harold Prosser. (Lisbon Historical Society.)

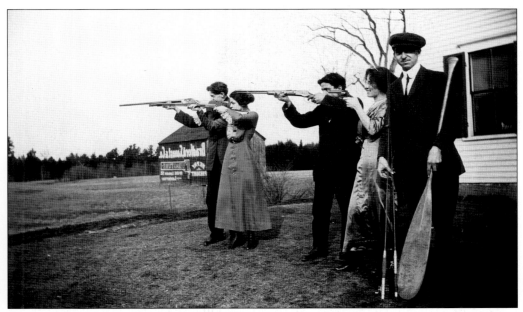

Target practice is shown near the Bradford Furniture building in Lisbon during the early 1920s. (Linda Gamrat.)

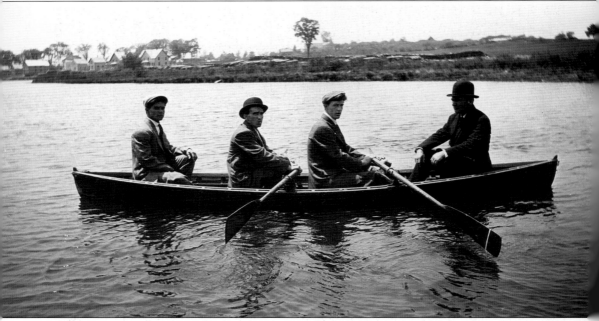

According to Lisbon legend, when businesspeople visited executives of the Farwell Mill, they would be given a canoe ride to a secret spot in the river, located somewhere behind Iva Millet's Cedar Lodge, where they probably stayed. There they would harvest freshwater clams to find what were called "the best pearls anywhere!" (Linda Gamrat.)

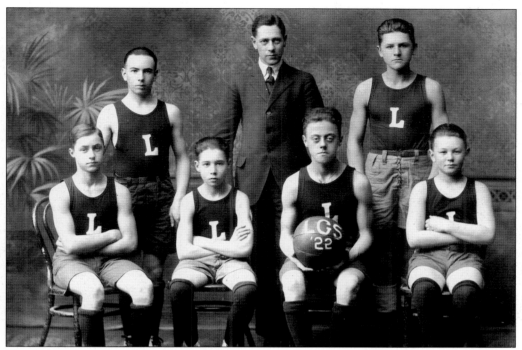

The Lisbon Grammar School basketball team of 1922 dressed six players. They included, from left to right, (first row) Stanley Stinchfield, Ovide Harvey, Lucien Arnoldy, and S. L. "Tony" McCarthy; (second row) Napoleon Gagne, Clarence P. Washburn, and Albert Blake. (Lisbon Historical Society.)

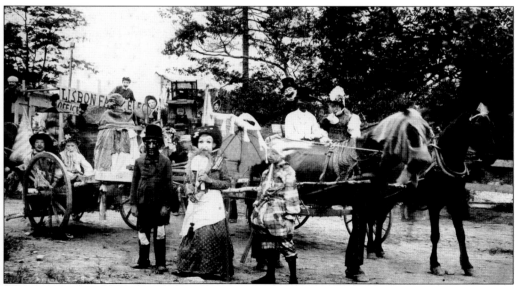

This interesting photograph is believed to be the "Horribles Parade" sponsored by the Lisbon Falls Electric Company in conjunction with a Fourth of July celebration. (Lisbon Historical Society.)

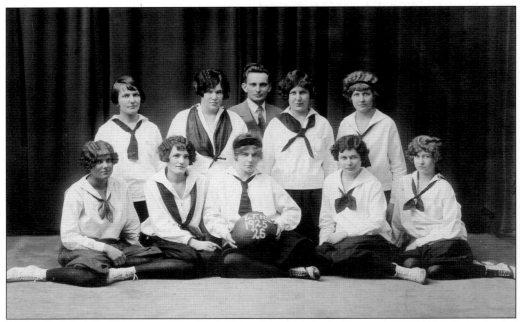

Nine members of the Lisbon Falls High School girls basketball team of 1925–1926 are shown in full uniform. The players include, from left to right, (first row) Ruth Parker, Frances Beals, Louise Tupper, Ginnie Schott, and Doris Clason; (second row) Billy Reo, Margaret Whittier, Z. Richardson, Ellen Burgess, and Geraldine Whittier. (Lisbon Historical Society.)

This is a men's pick-up game of baseball, probably taken in the early 1920s. (Linda Gamrat.)

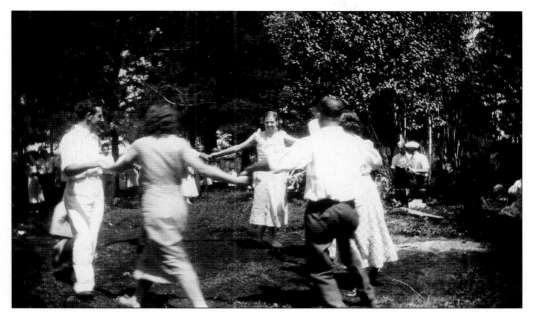

Townspeople gather for a picnic and dancing. On the right, a man is playing the accordion, perhaps brought from Germany (where the accordion was invented) by previous family members emigrating from their birthplace.

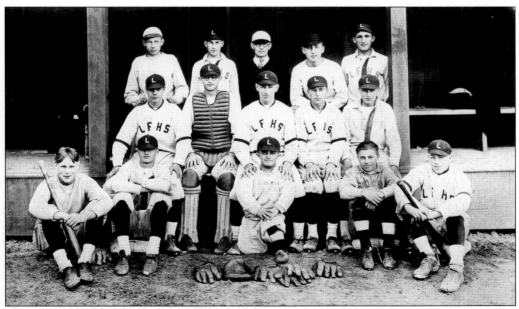

Here is the Lisbon Falls High School baseball team of 1927. From left to right are (first row) Howard Gerrish (second base), Lem Hill, Ben McGraw, ? Marchak, and Russell Holland (pitcher); (second row) Ken Harris (first base), Paul Dumas (catcher), Andrew Kiszonak (third base), Andy Adams (shortstop), and John Beganny (center field); (third row) Edgar Lemke, Lester Stover, Coach Sherman, ? Smith, and Steve Karkos (left field). (Lisbon Historical Society.)

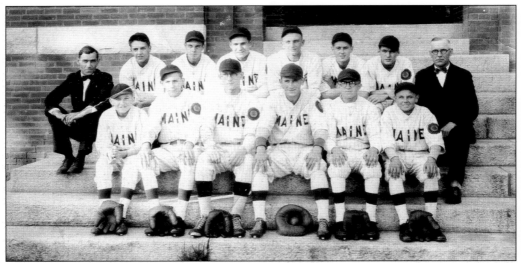

In 1929, Lisbon's Nelson Conley Post American Legion junior baseball team won the New England championships and played hard in the World Series in Washington, D.C., losing only the final game of the series to Buffalo, New York. Winners in the hearts of all Lisbon residents, the team was escorted home by a parade of cars and greeted with flags and banners throughout the town. Champion players, from left to right, are (first row) Frank Bichrest, George F. Batchelder, Mike Yecho, Andrew Elcik, George Davala, and Joe Sherbak; (second row) legion member Lee Woiles, Richard Reynolds, Walter Jenec, Joe Davala, John Galgovitch, Howard Atwood, Randall Coombs, and high school principal Herbert Bowman. (Lisbon Historical Society.)

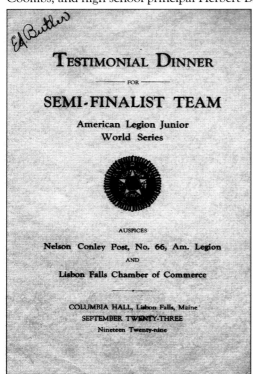

This is the program of the Testimonial Dinner held in the American Legion team's honor on September 23, 1929.

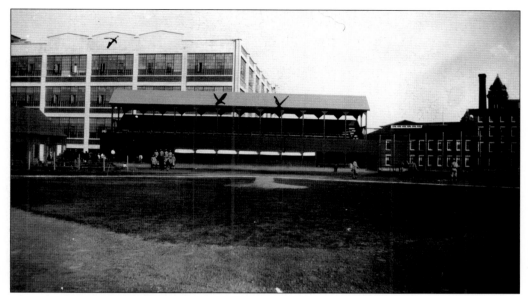

This is a 1936 photograph of the Worumbo Ball Park, home of the semiprofessional Worumbo Indians. The park held 2,000 fans and boasted dimensions similar to the old Yankee Stadium. Approximately 40 of the scheduled 60 games were played at the Worumbo Park each season. Admission to the park was 25¢. (Lisbon Historical Society.)

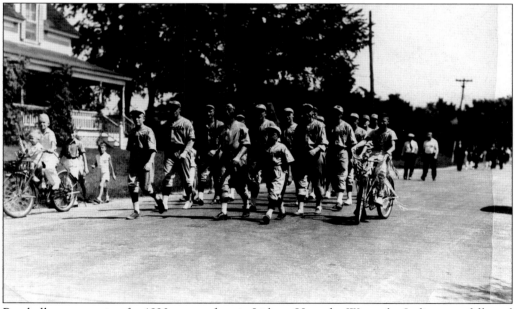

Baseball was a passion for 1930s sports fans in Lisbon. Here the Worumbo Indians are followed by avid supporters as they parade through the town upon their return from the nationals. The Indians won three state championships during the four years they played. In that short time, the team produced a major-league infielder, Eddie Waitkus, who went on to play for the Phillies. (Lisbon Historical Society.)

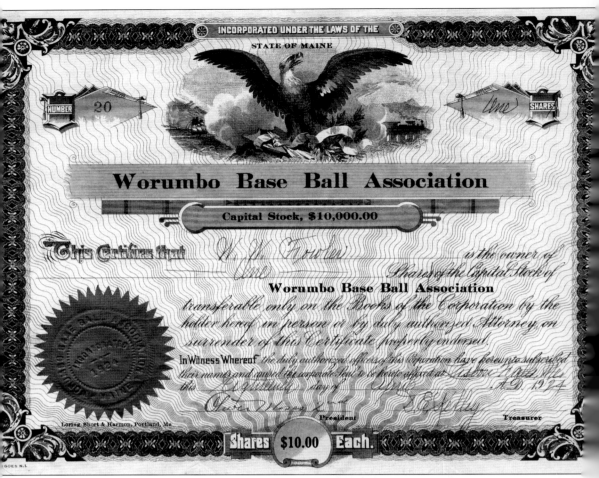

This capital stock certificate, dated April 18, 1924, belonged to William Wallace Fowler. This certificate was worth one share; each share cost $10.

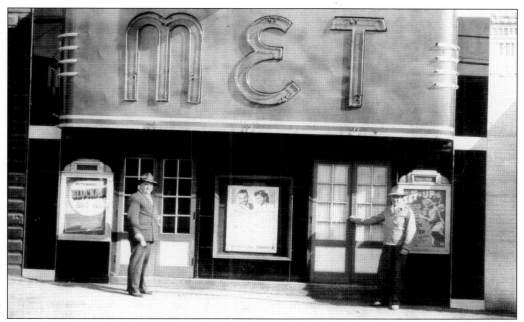

In 1937, George E. Neagle (right) moved from Connecticut to Lisbon Falls, where he opened the popular Met Theater on Main Street. With the help of his wife, Marion, and partner, Adam Sichol (left), Neagle operated the family theater for many years while also working at the Worumbo Mill. (Janet Cameron.)

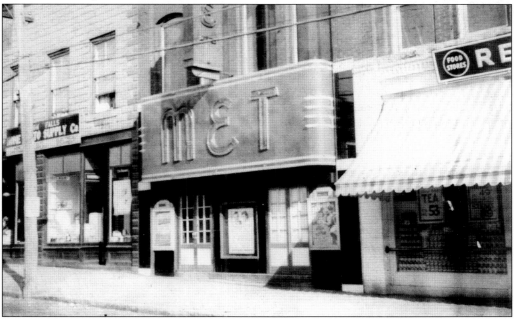

Located beside the Red and White Grocery, in the heart of the business district, the Met Theater offered Saturday matinees for 15¢. There were often double features, with exciting newsreels in between. Summer moviegoers were kept cool by fans that blew across large blocks of ice in the front of the theater. (Janet Cameron.)

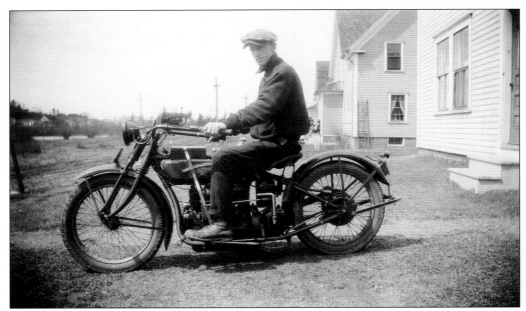

This is a great photograph of an early-1900s Indian motorcycle. The Sabattus River is in the background. (Linda Gamrat.)

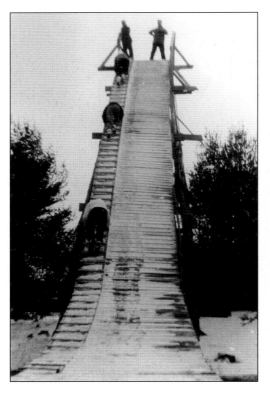

This ski jump provided many hours of fun and competition for Lisbon-area skiers. In the early 1940s, Russell Huston, in conjunction with Lisbon High School's winter carnivals, constructed a smaller ski jump in the midst of trees on land owned by the Worumbo Mill. Many of those who used the ski jump left Lisbon Falls for a time to enter the service. Upon returning to town after World War II, the young men received permission from the mill to cut the trees and construct a new jump. John Alexander sawed the trees into boards, and the men built this larger jump. Competitions were organized, and a coveted trophy was awarded to the winning ski jumper. (Alfred "Breezy" Galgovitch.)

Two

THE POWERFUL RIVER

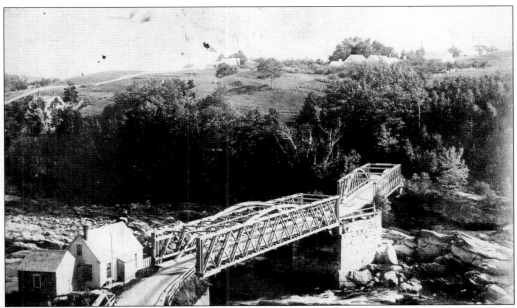

The Androscoggin River has served the Lisbon community well as a source of power, sustaining manufacturing and allowing the town to flourish and prosper. Friend and foe, the powerful flow to the Atlantic Ocean shaped the town's history, contributing to the beauty, recreation, and livelihood of the area. This 1800s postcard depicts the old toll bridge across the rushing Androscoggin, connecting Durham to Lisbon Falls for the first time. The tollhouse was built in 1818, and its first toll collector was Jeremiah Getchell. The wooden bridge remained for 77 years until it was replaced in 1895 by an iron bridge. (Harrison Wakely.)

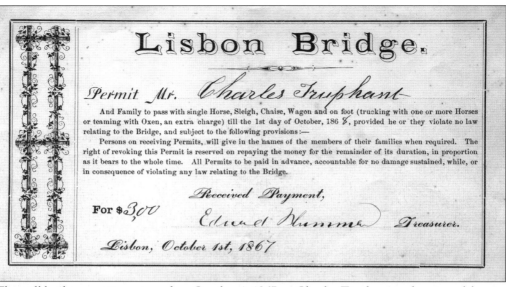

Lisbon Bridge.

Permit Mr. *Charles Truphant*

And Family to pass with single Horse, Sleigh, Chaise, Wagon and on foot (trucking with one or more Horses or teaming with Oxen, an extra charge) till the 1st day of October, 186 *8*, provided he or they violate no law relating to the Bridge, and subject to the following provisions:—

Persons on receiving Permits, will give in the names of the members of their families when required. The right of revoking this Permit is reserved on repaying the money for the remainder of its duration, in proportion as it bears to the whole time. All Permits to be paid in advance, accountable for no damage sustained, while, or in consequence of violating any law relating to the Bridge.

Received Payment,

For $*3,00*

Edward Plummer Treasurer.

Lisbon, October 1st, 1867

This toll bridge permit was issued on October 1, 1867, to Charles Truphant and was good for one year's time. (Harrison Wakely.)

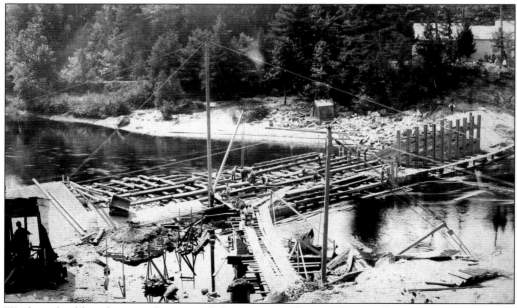

Workers build a dam at the site of the paper mill in Lisbon Falls, 1886–1887. (Lisbon Historical Society.)

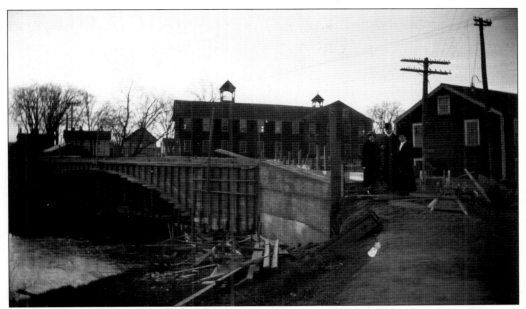
This photograph shows progress on the construction site of the bridge at the Farwell Mill in Lisbon. In the background is the Old Farwell Cotton Mill. (Linda Gamrat.)

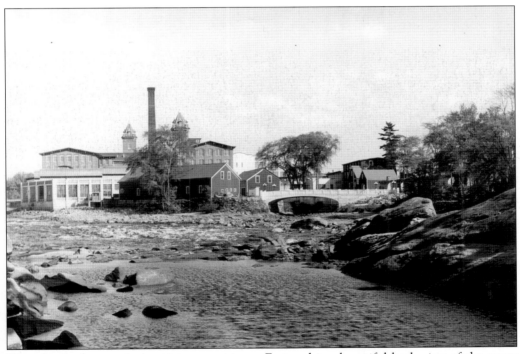
Here the Androscoggin is at its most reticent. Featured is a beautiful back view of the many facets of the Worumbo Mill. (Lisbon Historical Society.)

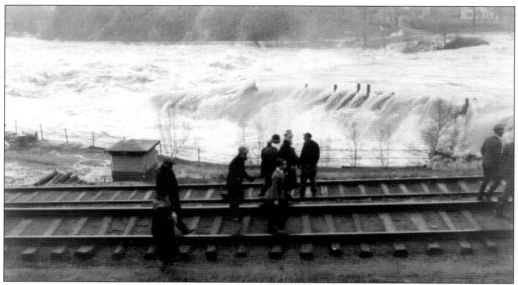

Lisbon's second-largest flood of the Androscoggin River inundated the town with its frigid waters and raging force in March 1936. (Lisbon Historical Society.)

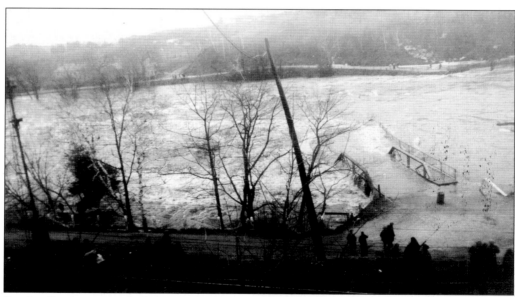

Surging floodwaters washed the iron bridge away, leaving Durham disconnected from Lisbon. The American Bridge Company replaced the structure with a steel bridge. (Lisbon Historical Society.)

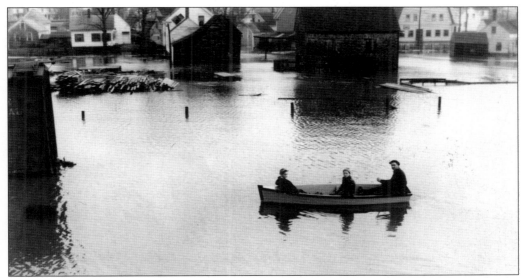

Widespread flooding left streets and homes underwater in 1936. Always resourceful, Lisbon citizens, temporarily displaced by the flood, found alternative means of travel through the downtown streets. (Lisbon Historical Society.)

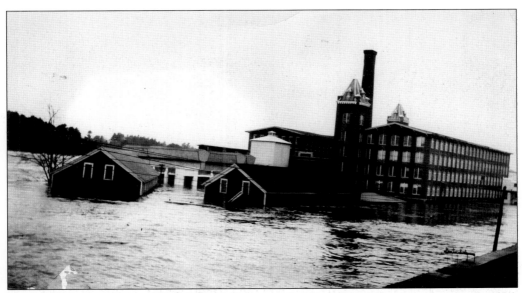

The Androscoggin River is the lifeblood of the town's mills, offering a source of power. In 1936, however, that very means of sustainability threatened to destroy the majestic Worumbo, filling it with floodwater and destroying valuable fabric-making machinery. (Lisbon Historical Society.)

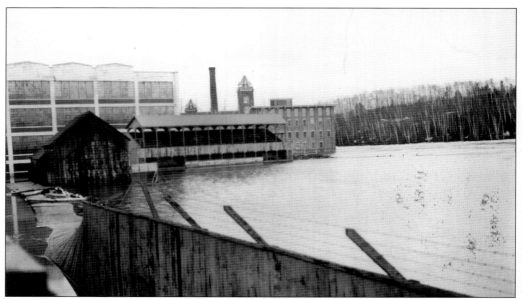

The grandstand of the Worumbo Indians Ball Park peeks over the flood as the entire field lies underwater. Only days later a baseball game was played in this very spot. (Lisbon Historical Society.)

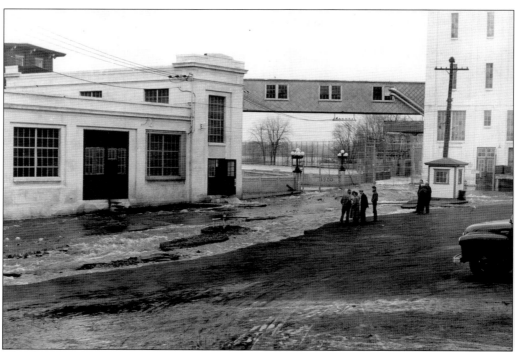

Water pours from the lower doors of the Worumbo as the flood recedes, offering a sign of hope as townspeople gather to assess the damage and begin the cleanup. (Lisbon Historical Society.)

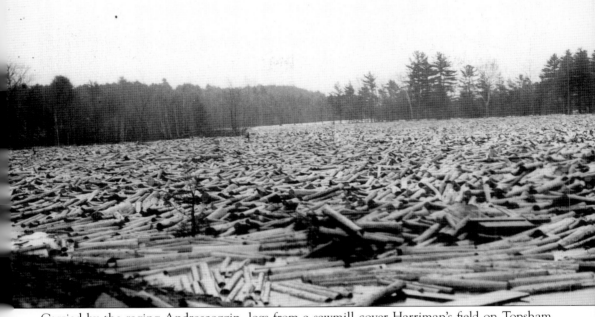

Carried by the raging Androscoggin, logs from a sawmill cover Harriman's field on Topsham Road as far as the eye can see. (Lisbon Historical Society.)

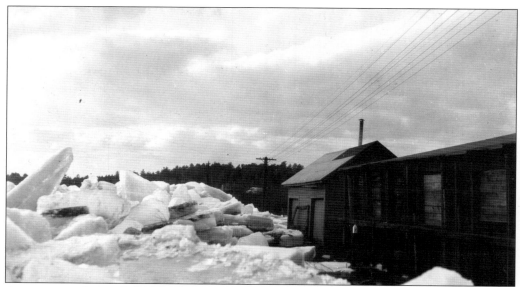

A mountain of ice, piled 15 feet high, was left at the train depot when a forceful ice jam let go on January 26, 1938. (Lisbon Historical Society.)

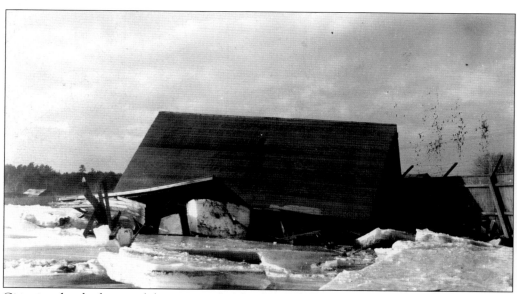

Giant ice chunks destroyed the upper end of the Worumbo Ball Park following the Androscoggin River ice jam of 1938. (Lisbon Historical Society.)

Three

MANUFACTURING, THE
FOUNDATION OF LISBON

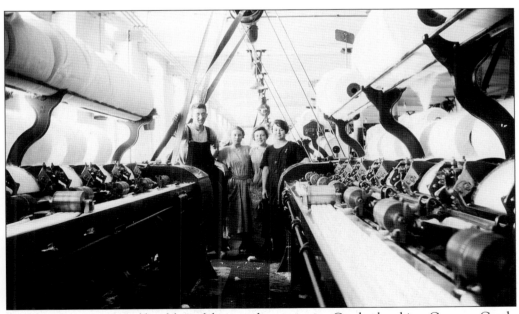

Escaping the tyranny and hardship of their mother countries, Czechoslovakian, German, Greek, Irish, Italian, French, and English natives fled to America seeking ways to sustain and nurture their families. In 1864, the Worumbo Mill was incorporated and the Farnsworth Mill was under construction. The Lisbon Falls Fiber Company joined them in 1889. These manufacturing giants were the foundation for the three villages of Lisbon. Offering honest work and a steady paycheck, the factories were appealing employers, attracting many industrious young workers. The major mills constructed housing complexes, offering rental apartments to a number of employees. Life was good in Maine, and families thrived in their new town of Lisbon.

41

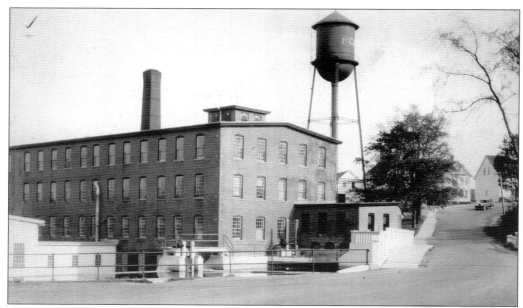

According to historians, the great Farnsworth Mill of Lisbon Center was named for Cephus Farnsworth, who purchased the water rights and machinery in 1825 from what was then the three Coombs Mills. The Farnsworth was a woolen mill from 1868 until the 1960s, processing cotton and wool products. Providing steady employment for hard-working locals, the mill was a great source of Lisbon pride. (Lisbon Historical Society.)

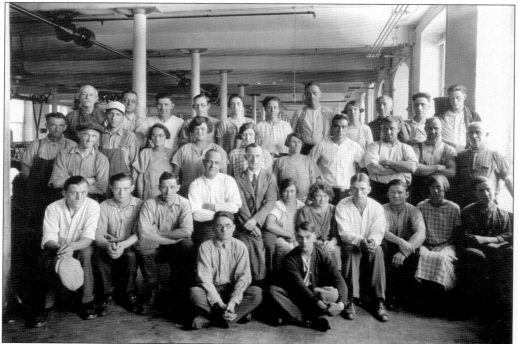

Shown here are some men and women, young and old, of the Farnsworth Mill. (Lisbon Historical Society.)

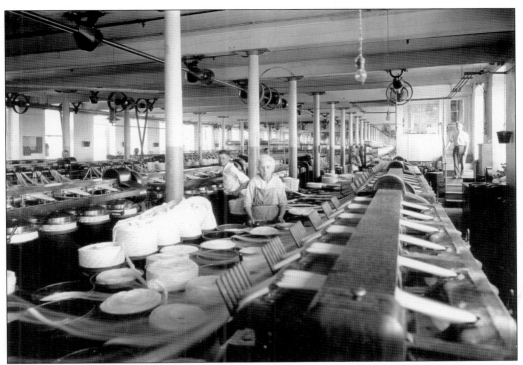

Pictured here is the roving and drawing room at the Farnsworth. (Lisbon Historical Society.)

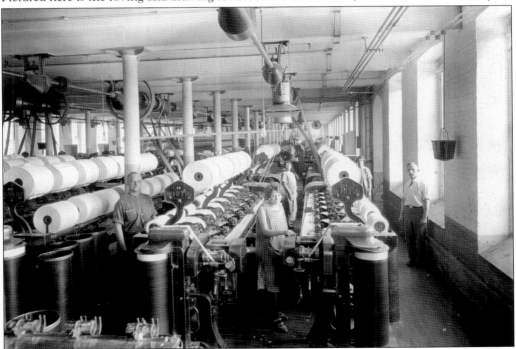

Generations of men and women worked side by side. Employees are pictured here at work in the spinning room. (Lisbon Historical Society.)

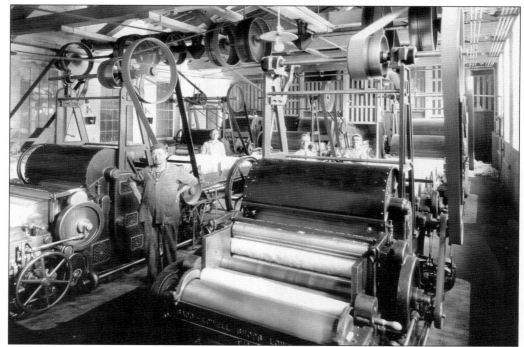

This grand portrait is of the carding room at the Farnsworth Mill. Employees included A. Gervais, H. Violet, and A. Lemieux.

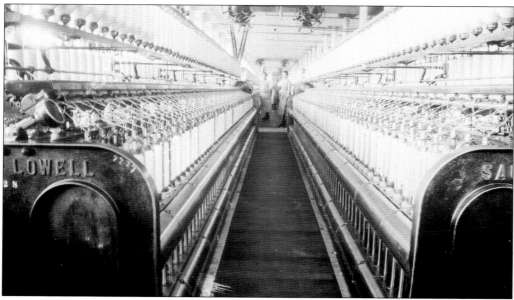

Massive machinery is pictured inside Farnsworth Mill in Lisbon Center. Employees stand in the background. (Linda Gamrat.)

Time, week ending Saturday, June 29 1912

Larry bri...

Time, week ending Saturday

NAMES.	S 23	M 24	T 25	W 26	T 27	F 28	S 29	Total Time	Rate p. day	$	Cts.	NAMES.	S 23	M 24	T 25	W 26	T 27
Eli King					9	5			14			A Pelly					
A Pelly	8	13	15	10	13	5		7d1/4		17	75	F Welch					
F Welch												H Toothaker					
H Toothaker	0	13	15	10	13	5		56	23¢	12	88	J Barritt					
J Grund	8	3						11	23¢	2	53	P. Touchette					
Chas Hobbs	8							8	23¢	1	84	S. J. Clark					
J. Barritt	8	13	15	10	13	5		64	24¢	15	36	E Touchette					
O. Gunther	8							8	24	1	92	Eli King					
M. Crafts	1¼							1'4d.	2.25	2	81	And Tim					
J Pelly	8							8		2	72						
Joe Crolian		13	15	10	13	9		60	21.5	12	90						
P Touchette		13	15	10	13	5		56	23¢	12	88						

A week-long entry from A. Pelley's Time Book of the Pejepscot Paper Mill (later the U.S. Gypsum Company) is dated Sunday, June 23 to Saturday, June 29, 1912. This fascinating record lists employees by name, their number of hours worked each day, the rate of pay per hour, and the total amount earned. For 64 hours of cutting, one employee earned $15.36. The payroll that week for 27 employees was $126.89 for a total of 684 hours worked cutting. (Thomas Huston.)

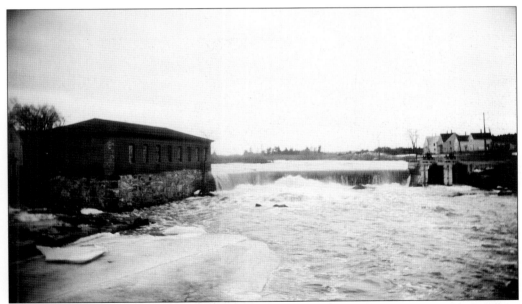

Shown on the left, next to the Farwell Mill in Lisbon, is the mill's gashouse. This unique building burned coal and distilled coal gas, which was pumped into the Farwell to use in gaslights at individual stations, allowing the workers to see at night. The gashouse is now a registered historical building, one of only 30 of its kind left in the country.

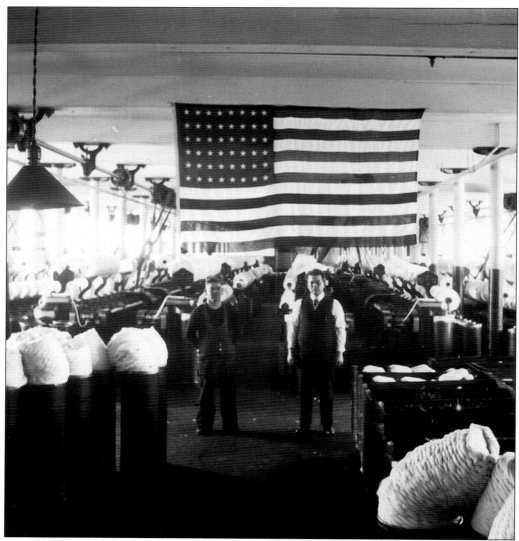

This picture shows employees on the fourth floor of the Farwell Mill. This is the spinning room where rolls of wool are spun into cloth. An American flag is displayed as a sign of patriotism, as immigrants from many countries, including Germany, England, Greece, France, Italy, Ireland, and Czechoslovakia work together for the common goals: family, work, and country. In the early 1900s, over four and a half million yards of cloth were manufactured every year at this mill.

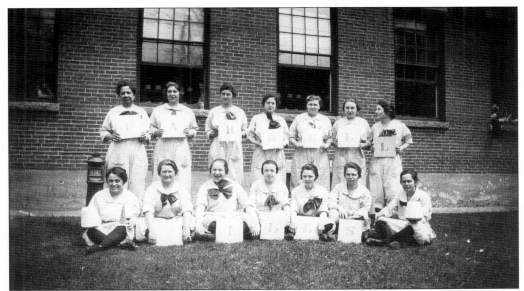

A group of female employees holds letter cards that spell "Farwell Mill," outside on the mill's lawn. Note the machinery and spools showing through the open windows while employees watch the activity at the windows. This is an early-1900s photograph. At that time, the Farwell specialized in unbleached napkins and sheeting material. Some employees worked 11-hour days at the factory, earning 8¢ per hour. Several children were among the laborers of the mill. (Linda Gamrat.)

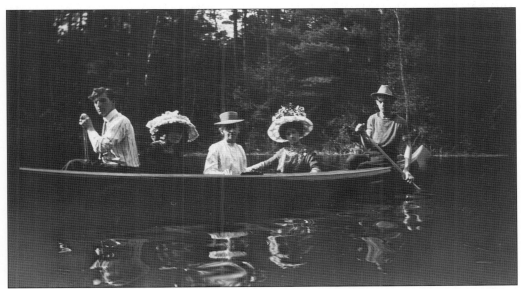

Three women, most likely the wives of executives doing business at the Farwell Mill, are paddled down the river. It was customary for businessmen visiting the Lisbon mills to stay at Iva Millett's exquisite Cedar Lodge located just below the Farwell Mill. The men would often bring their wives, who would be entertained by mill employees. These Sunday afternoon canoe trips offered the women a unique view of the area and a lovely way to spend the day. (Linda Gamrat.)

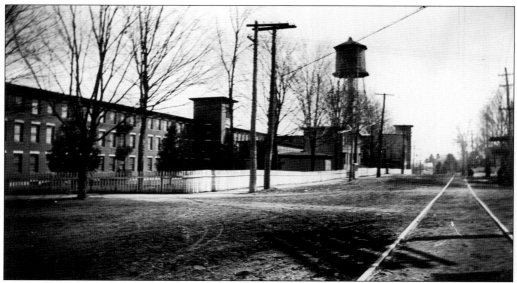

This early-1900s photograph of Lisbon's Farwell Mill features the grand brick manufacturing plant, its water tower, the dirt road, and trolley tracks that span from Lewiston to Bath. (Linda Gamrat.)

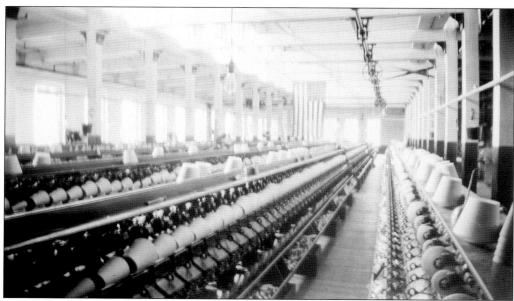

Hundreds of spools of cotton thread are pictured in this *c.* 1900 image of the Farwell Mill. (Linda Gamrat.)

The river is low in this picture. Across the river are a number of the apartment houses owned by the mill and inhabited by its employees. (Linda Gamrat.)

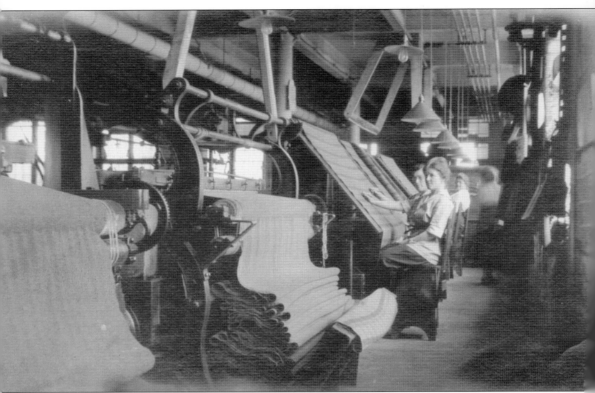

Worumbo employees work with massive amounts of cloth in the Finishing Room. With the earned reputation of producing the best cloth in the world, the Worumbo Woolen Mill takes its place in Lisbon's history as its foundation in manufacturing excellence. The original mill was established post–Civil War in 1865 and experienced improvements and additions, always maintaining the highest standards, even winning first place awards for its products in two world's fairs.

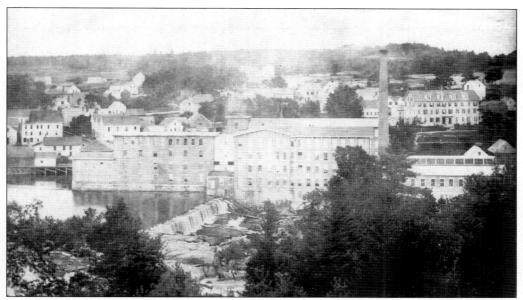

This is an aerial view, looking north of the Worumbo Mill and surrounding neighborhoods prior to 1920 and to the white mill addition. Just up a bit and a little to the right of the smokestack is the boardinghouse owned by Worumbo Manufacturing. (John Shaughnessy.)

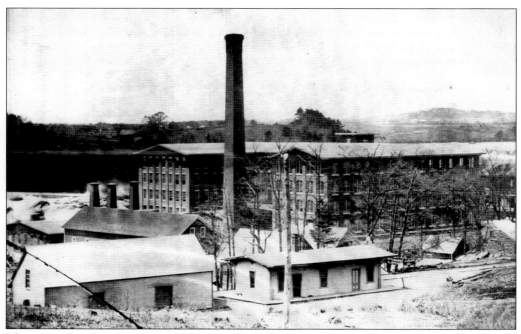

This is another shot of the pre-1920s Worumbo Mill. This view is looking to Durham, southwest. (John Shaughnessy.)

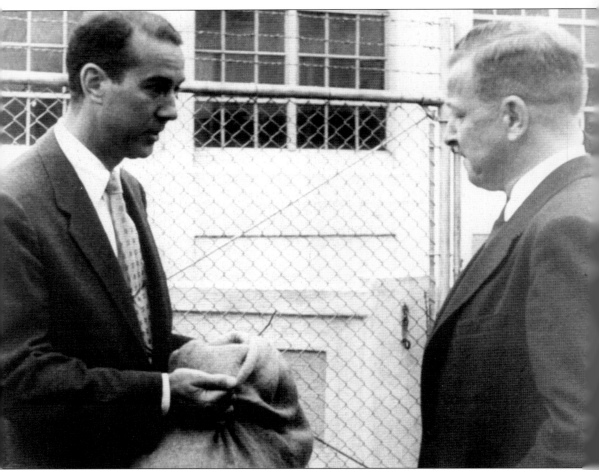

In 1954, contestants on the popular television show *Truth or Consequences* were given two live sheep and offered the challenge to have a suit made from the sheep's wood in just two weeks. Oliver Moses III from the Worumbo Mill invited the contestant to bring his raw wool to the mill to have woolen cloth made for his suit. The Worumbo has a worldwide reputation for producing the finest woolen cloth, so the contestant accepted the offer. In this photograph, the contestant is standing at the Worumbo's front gate, showing Moses his bag of wool.

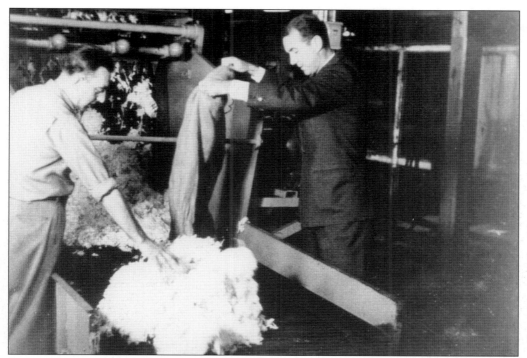

Pictured here is Arthur "Tuffy" Reynolds explaining the scouring (washing) procedures to the contestant. He tells him that all raw wool must be washed before it can begin to be processed into cloth.

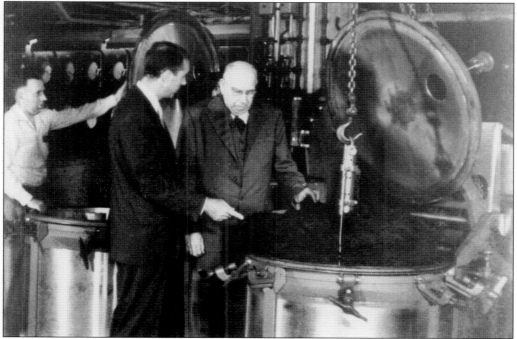

Next the wool must be dyed in giant vats.

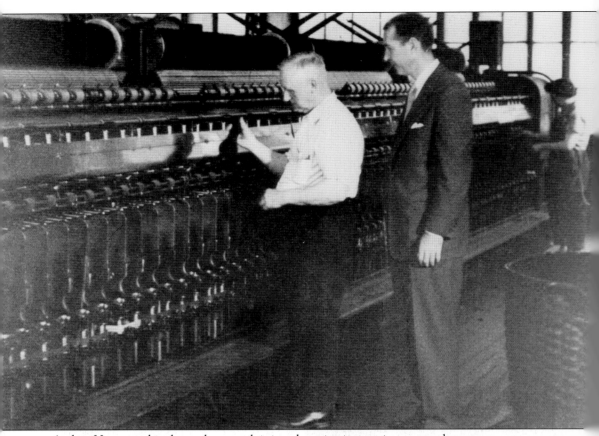

Arthur Hammond is shown here explaining the spinning equipment to the man.

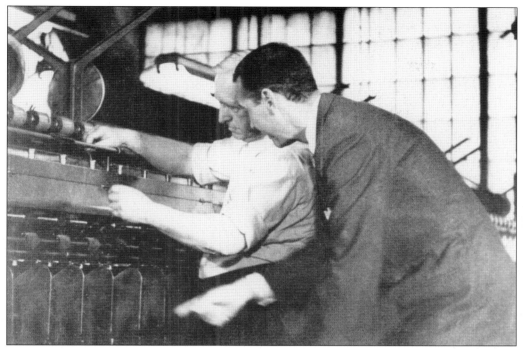

Making wool is a lengthy and sometimes intricate process.

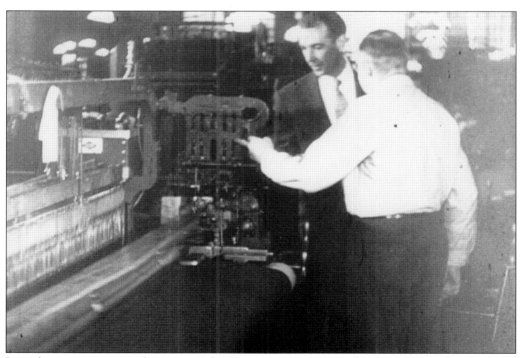

Into the weaving room they go as John Dinsmore points out the fine points of making the finished product.

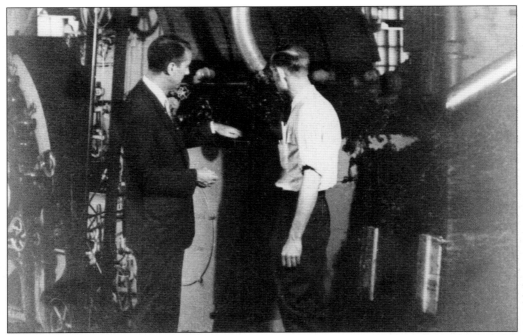

Otto Stewich, who came to the Worumbo Mill from Germany in 1930, shows the contestant the stretching techniques.

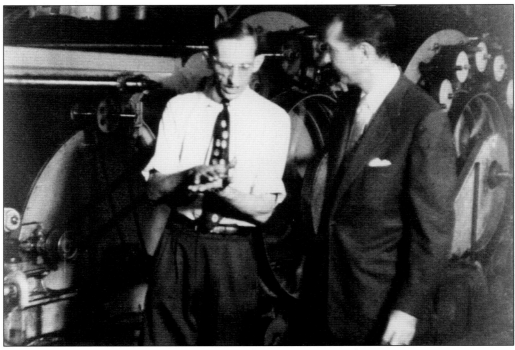

Stewich talks about folding the cloth. The contestant is an eager learner.

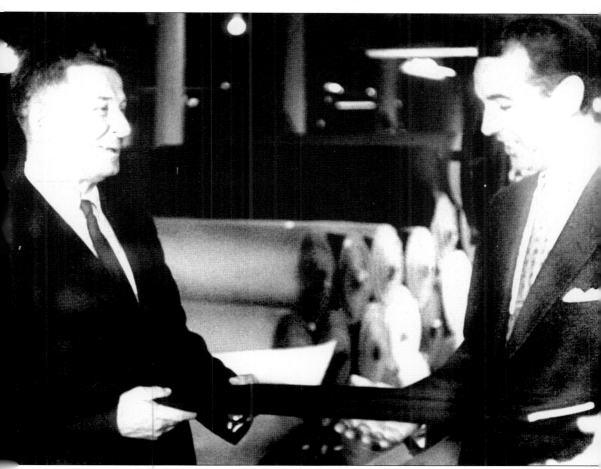

The contestant is handed the finished bolt of fine Worumbo cloth, custom-made just for his consequence. The man then takes the cloth to the tailoring firm of Hart, Schaffner, and Mark in New York City to have the Worumbo cloth made into a suit. He is measured, a pattern is made, and the suit is tailored just in time for his return visit to the Truth or Consequences show. It was an exciting event for the employees of the Worumbo Mill.

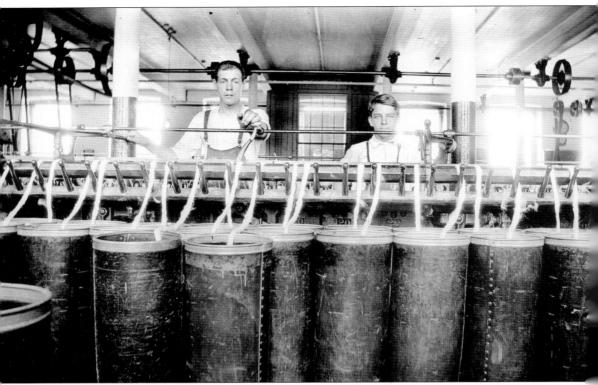

The work was hard in the mills, and some Lisbon folks spent the majority of their entire working lives producing award-winning cloth. The pride they felt in their work spilled over into all aspects of their lives, helping to make Lisbon the strong community that it is. Today residents still experience the effects of the earliest settlers' hard work, determination, strong traditions, and sense of community.

Seven

AROUND THE TOWN

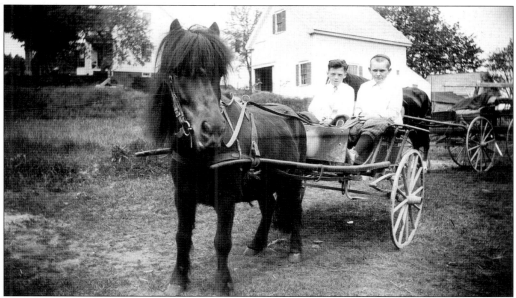

Lisbon, Maine, is a town of many assets. With its splendid natural resources and outstanding location, the three-village community is a winner in all respects. Among its many attributes are the expansive falls, majestic mills, and award-winning fabrics made by hard-working hands. Lisbon's history has provided town meetings, hotels, trolleys, mansions, Moxie, theaters, farms, and business districts. These landmarks are the everyday highlights of Lisbon; the assets that give the town character. For tourists, Lisbon has had its share of places not to miss, memorable and intriguing. For those fortunate enough to live here, Lisbon offers the everyday comfort of knowing the people, places, and things residents have come to rely upon. Around town, Lisbon is home.

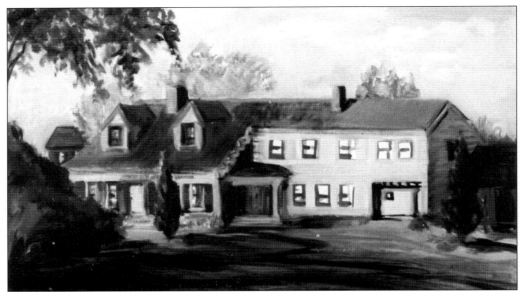

If walls could talk, this house would have a lot to say. Believed to be the oldest home in Lisbon, this dwelling has seen some enormous changes in the town. Although there is no real way to know the actual building date since the town's records were destroyed in the 1901 fire, historians believe that this house was probably built in the 18th century, perhaps in 1791. Almost as aged as the home, a sturdy elm stands tall over the charming residence on the fastidious property at High Street, Lisbon Falls. Known as the Yeaton house, the Bill Barr family now owns, and has lovingly preserved, this historical delight. This is an image of a 1930 painting by Eleanore Yeaton. (Bill Barr.)

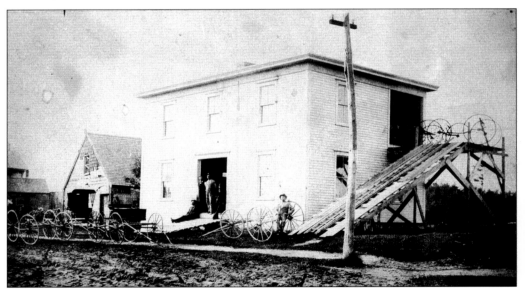

Wagons await repair at the Prince Repair Shop in Lisbon Falls. This photograph was taken by Roderick Bowie in 1886. Standing in the doorway, from left to right, are Daniel Estes, Sumner Littlefield, and Henry White. Millard Webber is seated; Harry Blethen leans on the wheels. The shop was later sold as a residence to Albert Risska. (George Huston.)

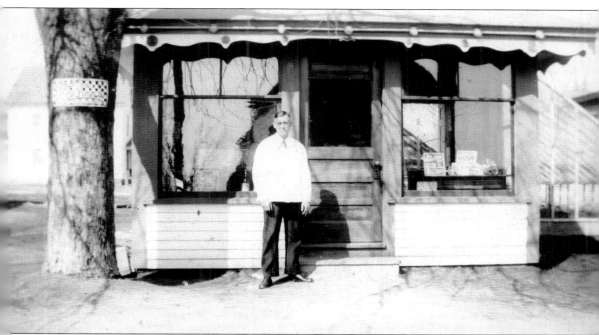

Here is a rare glimpse of the original Wheeler's store. Doc Wheeler began his professional life in Lisbon Falls as a chiropractor. He loved plants, grew luscious gardens, and decided to put up a greenhouse. It was not long before folks were requesting that he open it up for shoppers, which he did. The garden shop thrived. Next he was asked to sell a few groceries on the side; that idea expanded, too. He ultimately added a small grocery store in the corner of his own house lot, attached to his greenhouse. From there he added fresh meats, dairy products, and pickles in a barrel. Years later, when he was ready to retire, Doc sold his store to Charles "Chucky" Anderson, who took over in much the same fashion as the Wheelers. Both Doc and Chucky were beloved proprietors. Today Adept Screen Printing, owned by David Wallace and Larry Gardella, offers the same tradition of service established by the little shop's founders. (Barry Wheeler.)

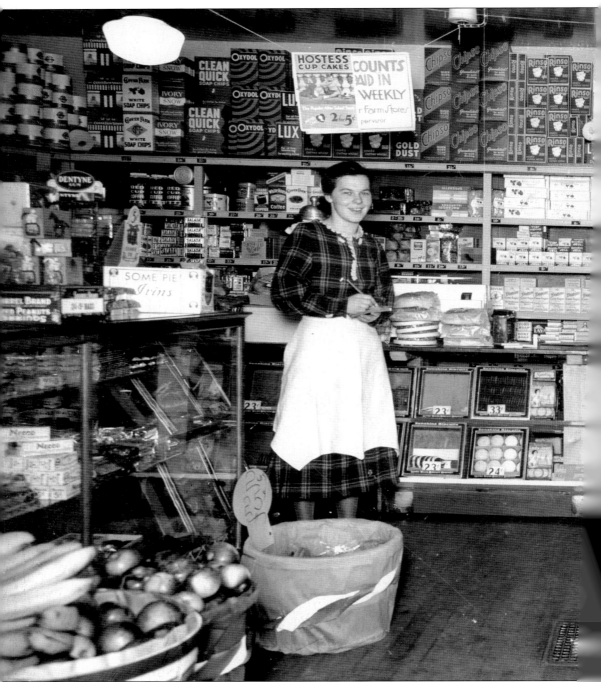

Shown is an inside look at Wheeler's grocery store (Clover Stores) with proprietor Carroll "Doc" Wheeler. The beloved Wheeler earned his nickname "Doc" when he moved his practice to Lisbon Falls in 1922 as Maine's first chiropractor. In 1932, he and his wife Cora Louise opened this market on Lisbon Street where they employed Lillian Morgan Lemke (pictured on left), a well-respected teacher and a writer. The Wheelers are fondly remembered for helping many

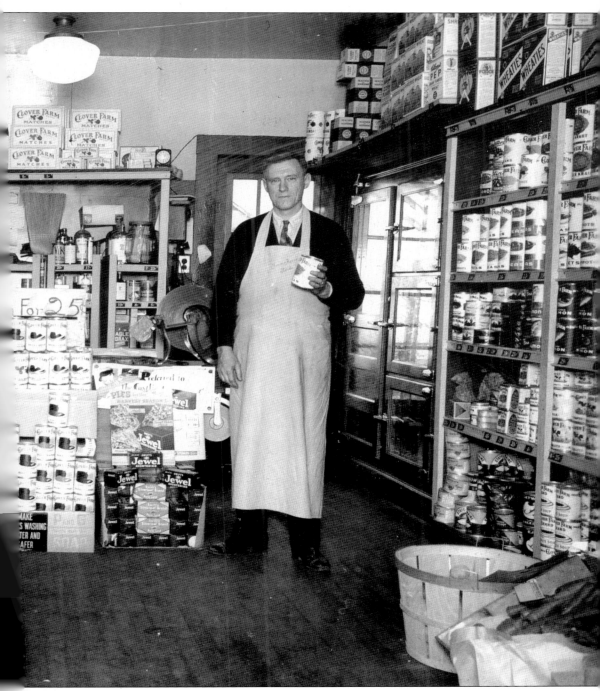

families through the Great Depression. A close look at the photograph reveals many interesting details, including a spool of string hanging from the ceiling and strung over to the reel of brown wrapping paper to the left of Carroll. Many Clover Farms products fill the shelves, as well as brands still recognized today, including Dentyne, Wheaties, and Hostess. Fresh produce fills bags and baskets on the floor.

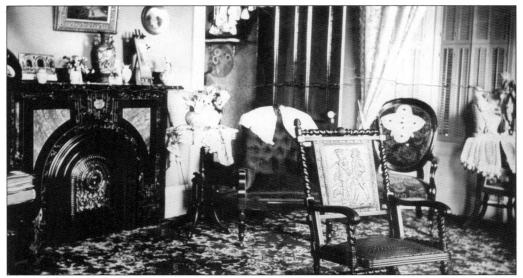

This is the parlor of the beautiful Victorian mansion built by businessman and Maine state senator Jesse Davis of Lisbon in 1867. The estate sat unpretentiously on a rise, just below the Farwell Mill. The grounds were kept as pleasing as the home. Ornate and luxurious, the elaborate home became Cedar Lodge, a tourist inn, when Alfred Goody and his wife purchased the property following Davis's death. Providing comfortable elegance to guests visiting the area, the Davis Mansion remained a popular attraction to everyone visiting the town. (Lisbon Historical Society.)

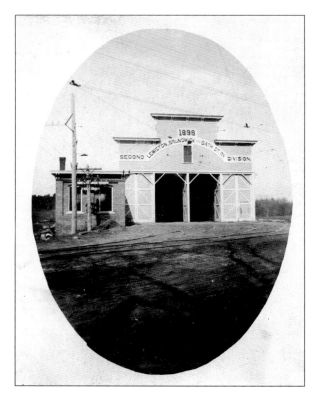

The car barn, used to house trolley cars for the Second Division of the Lewiston, Brunswick, and Bath Trolley, established in 1898, was located on Lisbon Road in Lisbon Falls. (Lisbon Historical Society.)

Guests are hereby notified that the Proprietor will not be responsible for Valuables, Money, Jewelry, etc., unless the same are deposited in the Safe at the Office.

W. B. JORDAN, Proprietor.

Manufactured and Sold by SMITH & SON, Bangor, Me.

Date.	NAME.	RESIDENCE.	Time.	Room.	Horse.
1885	J. C. Moore	Lisbon M.			
4	H. L. Channell	Bath. me			
	E. D. Magg	Skowhegan			
	J. J. Maher	Augusta M			1
	Arthur E. Allen	Biddeford Me			
	James D. Bickham	Winthrop Me.			
Mch 25	A. B. Hobart D	Port.			
26	H. L. Channell D	Bath, me			
	F. Wallace Jordan D	Lisbon me			
	B. H. Mitchell	Boston Mass			
30	H. L. Channell	Bath, me			
	Chas. E. Fraser & Wife.	Lick, Observatory Cal			
Apr 2	Ray Shaw	Its Falls			
	Frank C. Ritter	Portland Me			
	G. R. Copeland	Dexter me			
	Horace C. Friday	Lisbon Maine			
Apr 2	F. M. Little	Portland me	3	17	27
3d	F. C. Lancy	"			
	Saturday April				
	J. C. Lancy	Portland			
	Grover Cleveland				

This is an original page taken directly from the Lisbon Hotel registry. Dated 1884, this day's hotel guests included Grover Cleveland (signature at bottom of page). Owned and operated by Wentworth B. Jordan and his wife for 33 years, beginning in 1876, the hotel housed guests from all walks of life. Located on the corner of Spring and Main Streets, the inn had a well-earned reputation for delicious meals, fair prices (50¢ per night, two meals included), and extraordinary service. (Lisbon Historical Society.)

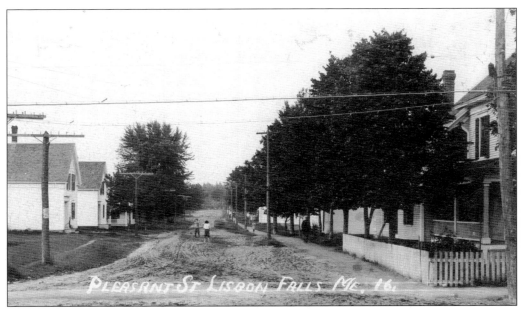

This postcard offers a very early look at the Pleasant Street, Lisbon Falls neighborhood. Shown on the left is the Gorey home and farther down, covered by trees, became the beloved Dr. Mendes's house. Down the street (fifth house) now live Alfred and Dorothy Smith of the Lisbon Historical Society. The Stanley Schultz home is on the right corner. (Dot Smith.)

The removal of a piece of Lisbon's history is captured as trolley tracks are permanently pulled up along Lisbon Road around 1941. (Lisbon Historical Society.)

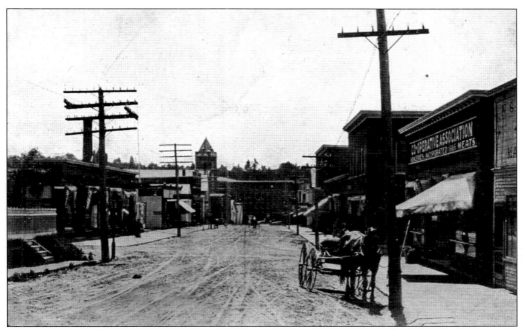

Shown is the Cooperative Association on Main Street in Lisbon Falls where townspeople could buy groceries and meat in bulk. Known as the Co-op, this market was considered the largest of its time in the community. Members of the Co-op could purchase shares at $5 each; there were 300 members in 1885. This view is believed to be shortly after the 1901 fire, with most of the buildings in brick. The Lisbon Falls Library is housed here today. (Dot Smith.)

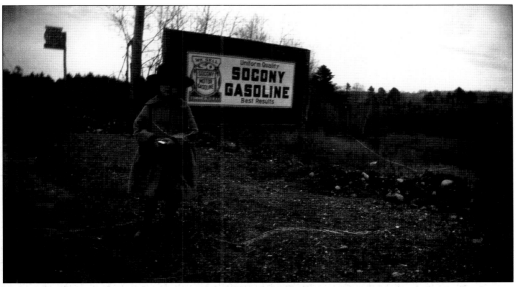

A little girl stands alongside a Socony gas billboard, which was one of the first street-side signs in the town of Lisbon. Socony was the acronym for Standard Oil Company of New York, established by John D. Rockefeller in the early 1900s. (Linda Gamrat.)

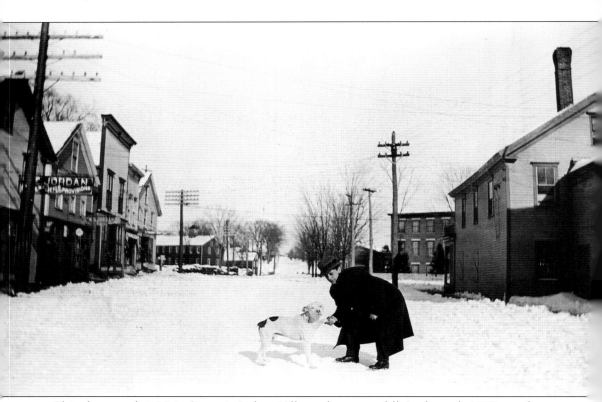

This photograph is Main Street in Lisbon Village after a snowfall. In the early 1900s, road crews would use a roller-type machine to literally pack down the snow on the roads. A grocery store owned by F. E. Jordan is shown on the left. Farwell Mill is across the main road in the distance on the right, and across from that stands the old Farwell cotton mill.

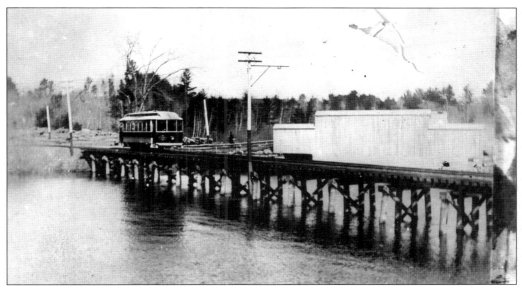

A closed trolley crosses Little River between Lisbon and Topsham. The Lewiston, Brunswick and Bath Street Railway trolley line was built in 1898. Two name changes and 43 years later, the tracks were taken up and the era of the Lisbon trolley service ended. (Lisbon Historical Society.)

Two men and a boy wait for the trolley at the Lisbon Waiting Station. The water tower from the Farwell Mill can be seen in the reflection at the left. (Linda Gamrat.)

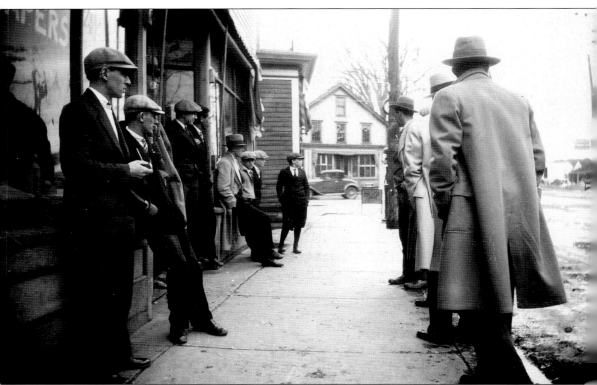

Men are waiting in front of Smyte Berube's store, which is next door to Lisbon's trolley waiting room. Smyte Berube is noted as selling everything from beer and roasted peanuts to ice cream, candy, and paper dolls. Directly across the street is the Farwell Mill. A Model A is parked at the end of the sidewalk. (Linda Gamrat.)

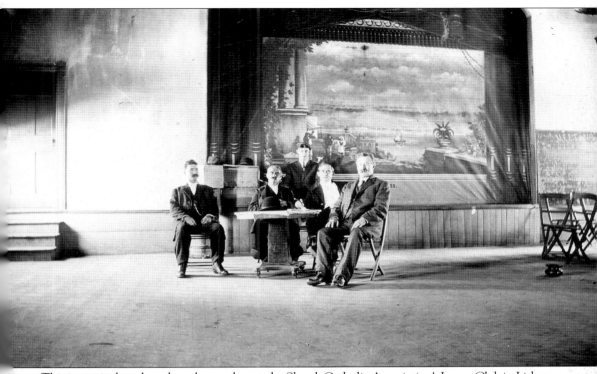

This image is thought to have been taken at the Slovak Catholic Association's Lower Club in Lisbon Falls. Shown are club members seated in front of an artistic backdrop, which was likely used in the production of plays or for dances—part of the activities that were regularly scheduled by members. Note the meeting agenda on the blackboard and the spittoon on the right. (Linda Gamrat.)

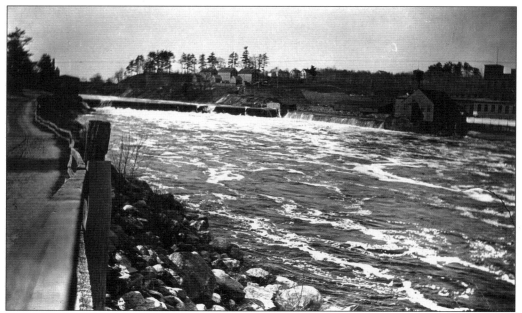

This is a scene from the Durham side of the Androscoggin River, following the dirt road and low wooden guardrail, along the edge of the water. On the far right is the Pejepscot Paper Mill. Above the mill are boardinghouses, owned by the mills, where employees could live a little more frugally than in town.

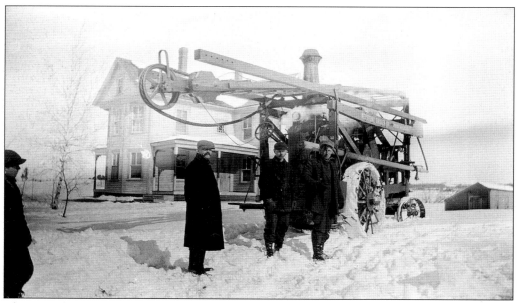

This complex-looking machine is a 1920s Keystone well driller, manufactured in Beaver Falls, Pennsylvania. Here it is shown in the snowy driveway of a rural Lisbon home. (Linda Gamrat.)

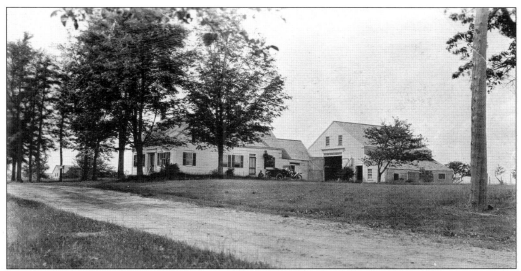

Pictured is the David and Georgianne Fillion House on Ridge Road in Lisbon. The home was built in the 1800s; the Fillions purchased it in 1924. This photograph was taken in the 1930s. Their son, Marcel Fillion, recalls the cooking fireplaces in the home. His father was a mill worker and farmed this 30-acre homestead, raising beef, hogs, chickens, and vegetable gardens. (Ken and Arlene Harris.)

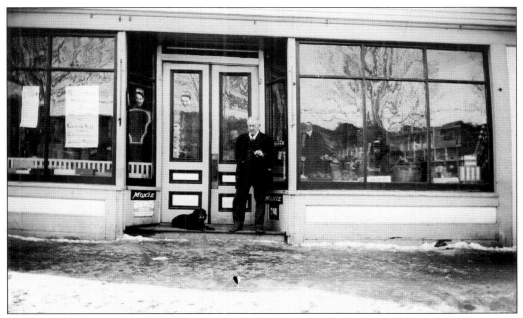

This storefront sports Moxie signs in its windows. Not only is the carbonated drink part of Lisbon's folklore, it is part of its history also. Believed to be the first mass-produced soda, it is now the official soft drink of Mainers, and most definitely of Lisbonites. Each year thousands of visitors flock to Lisbon for an entire weekend devoted to celebrating this unique soft drink in the bright orange can. (Linda Gamrat.)

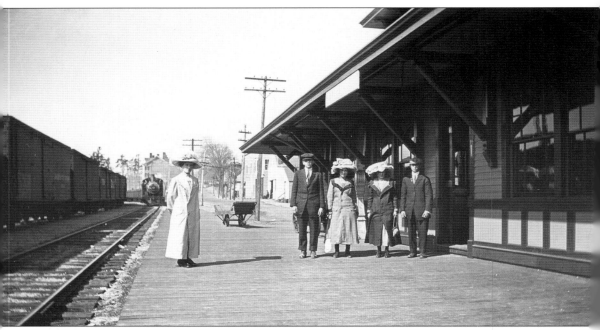

Ladies in fashionable hats and their male companions wait to board the oncoming train at the Maine Central Railroad Depot in downtown Lisbon Falls. This depot was built in 1910. (Lisbon Historical Society.)

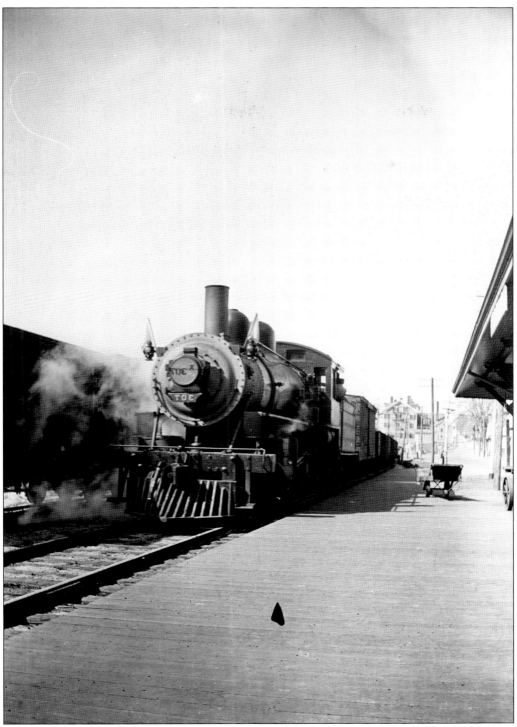

Maine Central Railroad engine No. 307 is pictured as it enters the station in Lisbon Falls on its way to Brunswick. Formerly Androscoggin Railroad, Maine Central took over in 1911.

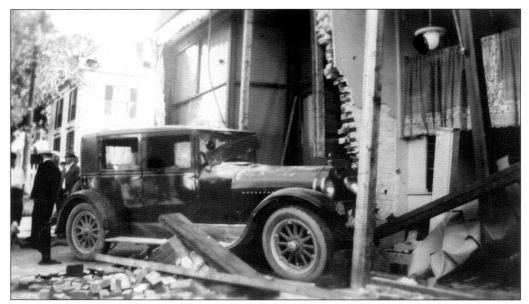

When Jack Herman of Lewiston swerved to avoid hitting Michael Drottar and family on the corner of Maple and Main Streets in Lisbon Falls, his vehicle ran up over the sidewalk and crashed into the show windows of F. E. McCue's store. In this August 1928 accident, supporting columns of the store, in addition to brick walls, were destroyed, totaling $500 in damages. (Lisbon Historical Society.)

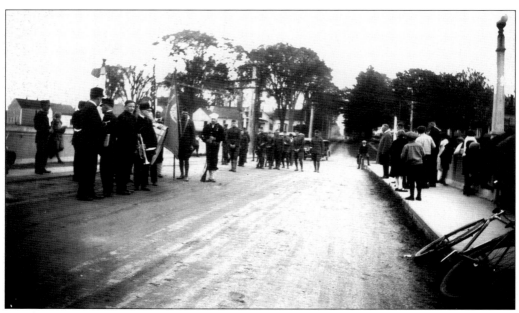

Parade participants and observers gather on the Farwell Bridge to prepare for the start of the Memorial Day parade, around 1916. (Linda Gamrat.)

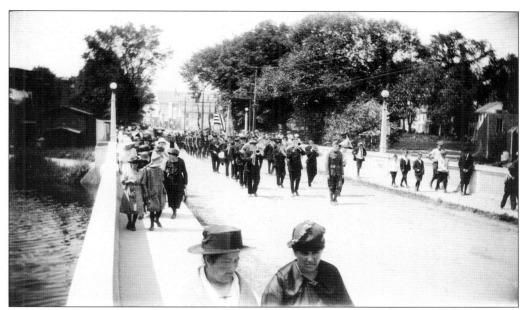

A band leads the Memorial Day parade across the bridge next to the Farwell Mill for the wreath-throwing ceremony. (Linda Gamrat.)

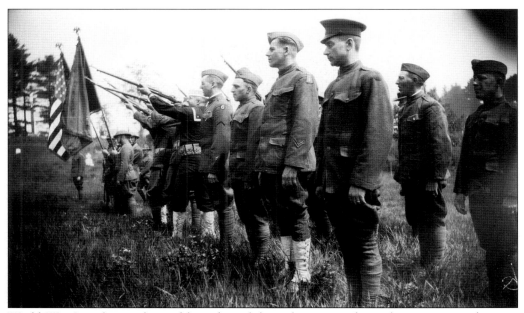

World War I uniforms of varied branches of the military provide a solemn presence during a ceremony at a rural cemetery in Lisbon. (Linda Gamrat.)

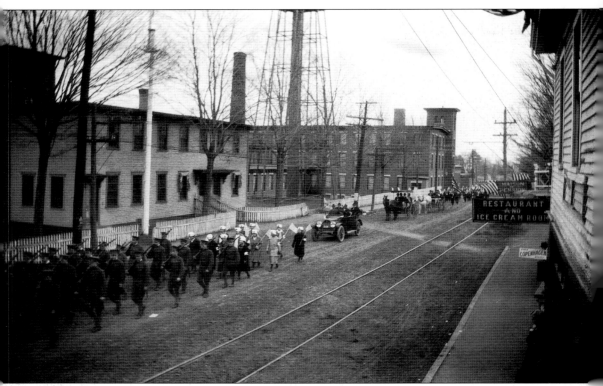

The Memorial Day parade marches alongside trolley tracks, past the Farwell Mill and its offices, and as far down the dirt road as the eye can see. Sporting World War I uniforms, the army and the navy are represented in the parade. (Linda Gamrat.)

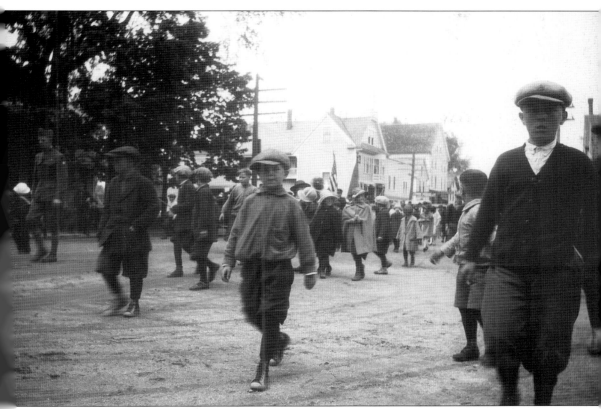

Kids in knickers and high-top shoes help to remember the veterans on Memorial Day during World War I. In Lisbon, parades were whole-town events. Townspeople were either in them or watching as welcoming bystanders. (Lisbon Historical Society.)

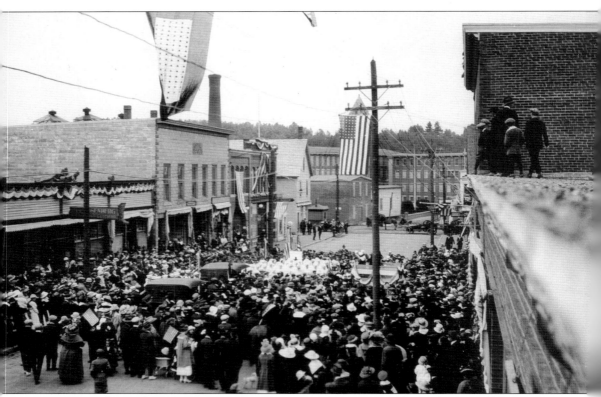

Lisbon Falls residents burst into the streets in celebration as the end of World War I was announced. Perched atop buildings, into doorways, and packed onto Main Street, crowds of folks, some immigrants with unique perspectives of the war, listened to speeches and celebrated a special day on November 11, 1918. (Ken and Arlene Harris.)

Five

A HEROIC TRADITION

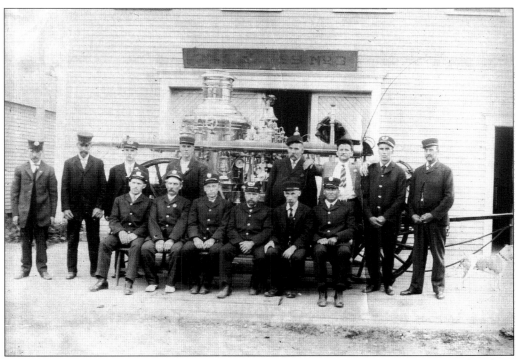

Shown is the early-20th-century Lisbon Falls Fire Department. The firefighters of the three Lisbon villages are more than brave men doing a job. They are a brotherhood, an elite club, and a heroic troupe. To be a firefighter in Lisbon is to be someone special. Whether responding to a call for help, competing in a fireman's muster for fun and glory, celebrating America in a local parade, or teaching fire safety to youngsters, these special forces are historically some of Lisbon's finest citizens and are respected and endeared.

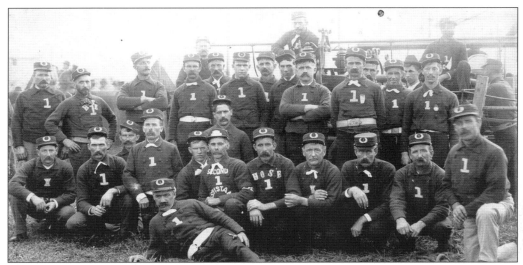

This hose 1 firefighters photograph was probably taken in the late 1800s to early 1900s. Pictured from left to right are (first row) John Foster; (second row) Lester Gilpatrick, Wallace Whitney, George Andrews, Ernest Conway, Walter Pevley, John Goddard, Forrest Jordan, Frank Haley, George Cotton, ? Bernier, Fred Young, and Sirois Robertson Sr.; (third row) Charles Slater, Ernest Allen, Charles Rideout, Arthur Chandler, John Atwood, Ben Atwood, Frank Proctor Jr., Frank Proctor Sr., Ed Alexander, Lewis Robertson Jr., Elmer T. Smith, Robert Forster, Len Failes, Herbert Proctor, Fred Fluellin, Charles Bickford, Robert Coombs, and Tom Patterson. (James Fournier.)

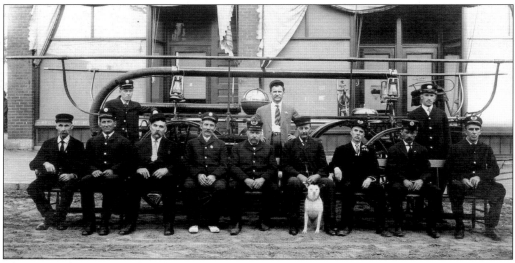

The General Bates No. 3 hand tub, named for Gen. James Lawrence Bates of the Civil War, was believed to be the oldest machine of the Lisbon Falls Fire Department. It was purchased just three years before the great fire of 1901, which destroyed the fire station on Maple Street and the entire business district of Main Street. The General Bates is still owned by the town and is displayed in a New York City firefighting museum. Pictured is the General Bates Engine Company of 1902. From left to right are (first row) Mike Coughlin, Fred Curtis, Sidney Bowie, Howard Curtis, James Gunther, Nathan Coombs, John Bartlett, Joseph T. Karkos Sr., and Clarence Proctor; (second row) Amil Eye, George Mihaylo, and William Littlefield. (James Fournier.)

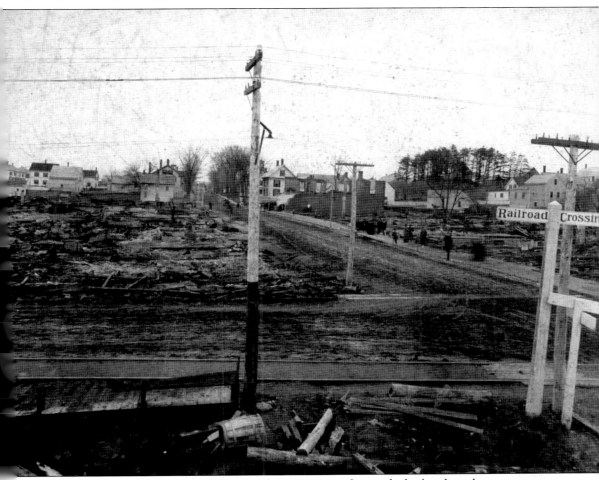

Railroad Crossin[g]

In the wee hours of the morning on April 6, 1901, tragedy struck the bustling downtown area of Lisbon Falls in the form of flames. Thought to have started in a shop in the Everett Block, the ravenous fire quickly consumed Main Street, burning everything in its path. The General Bates Firefighting Company fought courageously against its flaming foe, managing to save a good number of homes. Sadly, more than 30 businesses were incinerated and 50 families lost their homes. While the fire was a destructive blow to the economy, the townspeople rallied and rebuilt the area into a rejuvenated downtown that has thrived ever since. This photograph shows townspeople, shocked and saddened, viewing the devastation to their town. Eerily, a railroad crossing sign stands boldly in the midst of the ruins. (Lisbon Community Library.)

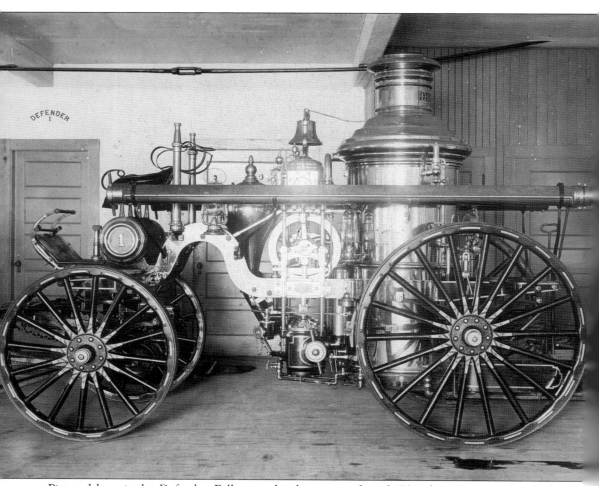

Pictured here is the Defender. Following the devastating fire of 1901, the town of Lisbon Falls purchased one of the finest fire engines in Maine for $5,000. The Metropolitan Engine could deliver 650 gallons per minute. A team of six horses pulled the magnificent equipment. (James Fournier).

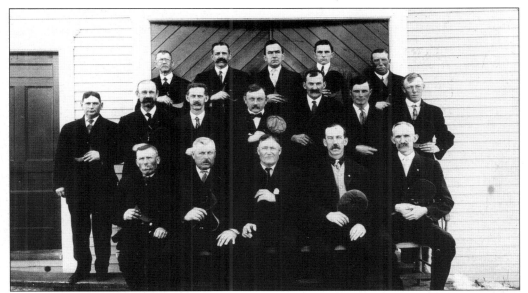

Lisbon's first department was named Torrent No. 1. A Hunneman hand tub was the town's first recorded firefighting machine. This 1908 image shows Torrent No. 1 firefighters. Shown here are the following, from left to right: (first row) Thomas Patterson, Fred Coombs, Gus Douglas, Bert Coombs, and George Andrews; (second row) Winfield Millet, Leonard Fales, Benjamin Atwood, Elmer T. Smith, Robert Foster, Chester Wallace, and Ernest Leighton; (third row) Asa Wendell, Forrest Jordan, George Golder, Elmer White, and George Smith. (James Fournier.)

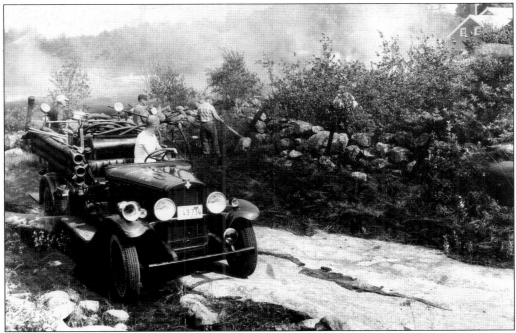

In 1922, the E. T. Smith Hose Company of Lisbon purchased a Ford Model T chemical fire engine built by American LaFrance. The Lisbon Falls Fire Department bought one also. This photograph shows firefighters using the new truck to battle a brush fire in Lisbon. (Mark Veilleux.)

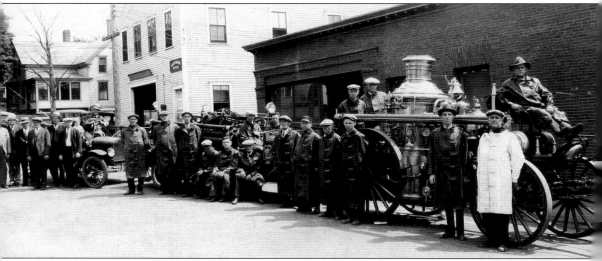

The Lisbon Falls Defenders are shown with firefighting equipment in front of the Maple Street station in this *c.* 1930s photograph. Pictured, from left to right, beside the Model A are selectmen Frank Burrell, Walter Lemke, and Hubert Bowie; fire wards Francis Plummer, Arthur White, and Joseph Pippin; and chemicals Richard Dugas and Fred Dugas. Standing by the Model A are George Dugas, Kelly Batchelder, and Fred Risska. Seated on the running board are William Holland, Amel Eye, and William Risska. In the cab are Robert MacIntosh and Osborne Bailey. On the rear step of the steamer are John Wonneberger and Bert Coombs. Standing are Ernest Bartlett, Nelson Danforth, Charles Bartlett, Clarence Goddard, Howard Warren, and Frank Coombs. Ellery Jones is in the driver's seat.

Capt. William G. Risska of the Lisbon Falls Fire Department was the community's only firefighter to lose his life in the line of duty. Risska died fighting the October 4, 1936, fire at Lisbon's century-old Cowing Tavern.

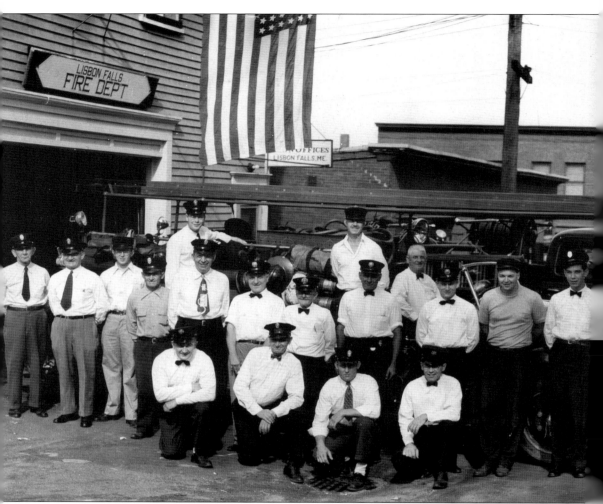

This photograph shows the men of the Lisbon Falls Fire Department of 1948. Pictured from left to right are (front row) George Elcik, Joseph Dupal, Linwood Hammond, and John Shaughnessy; (second row) Joseph Baumann, Joseph Karkos, David Hale, Paul Marquis, John Agathos, Mike Karkos, Linwood Small, Henry Roberts, Ralph McIntosh, Eben Reynolds, and Richard Elcik; (third row) Richard Cota, Thornton Stover, and Frank Whittier. In the background are two trucks. The front truck is a 1936 Ford/McCann rotary pump. In the rear is a 1948 Ford Am Lafrance.

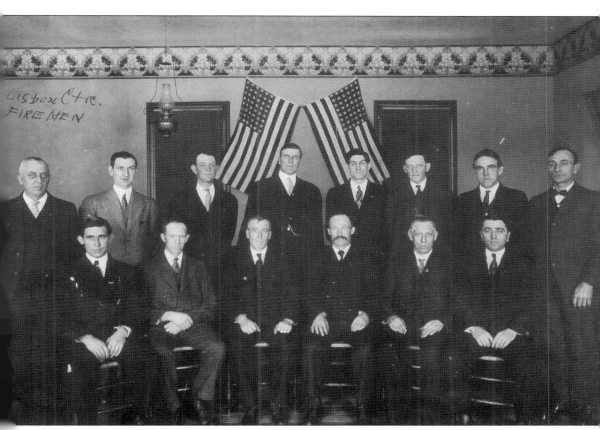

Shown is a rare photograph of the Lisbon Center firemen, probably taken in 1911.

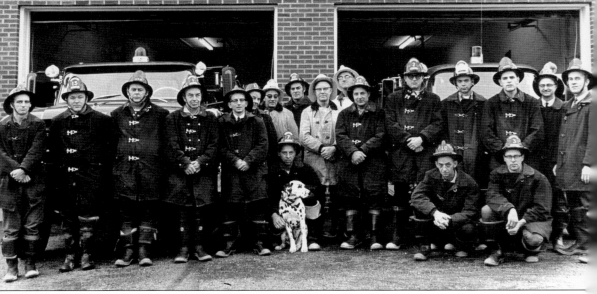

The men of the Lisbon Fire Department pictured are, from left to right, Jim Ross, George Ruby, Joe Burroughs, Frank Paul, Moe Fortier, Garnet Gartley, Milton Bowie, Roger Levesque, Ben Doboga with Duke Doboga, the department's firedog, Ellis Gartley, Howard Ricker, Joe Lapointe, Winston Smith, David Breton, Vern Ricker, Albert Carville, John Harris, Oliver Caron, and Moe Breton.

Six

EDUCATION AND
RELIGION

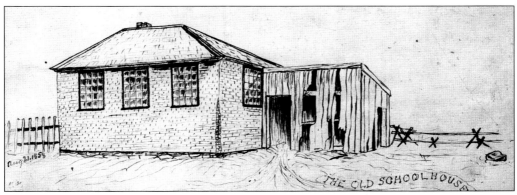

The many churches and schools of early Lisbon reflected the diverse population of migrating families in celebration of newfound freedoms. This is the original 1858 sketch of the Little Brick Schoolhouse, the very first school built in Lisbon Falls. King Cowan, who owned a local brickyard, built the one-room schoolhouse and offered it as a gift to the town in 1809. With $250 appropriated at a town meeting for the purpose of education, school was in session. In 1921, Arthur Stebbins purchased the historic building, and it remains a residence today. (George Huston.)

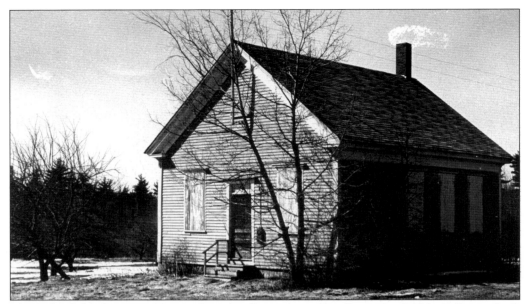

The Ridge School, a one-room wooden schoolhouse located on Route 9 in Lisbon Falls, was built in 1874. Attendance averaged anywhere from 4 to 18 students. Teachers were paid $5.50 per term for spring and fall, and $10 for winter. After several closings and reopenings, the school board closed the school permanently, and, in 1973, ownership transferred to the Lisbon Historical Society for renovations and preservation. (Lisbon Historical Society.)

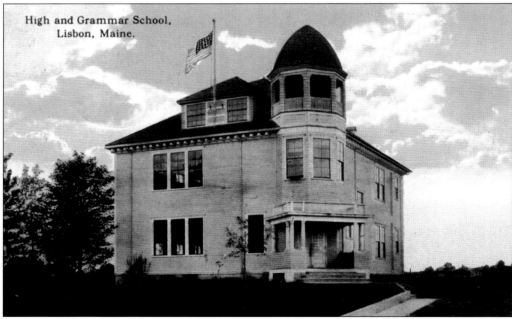

This school was built in 1893 on Lisbon Road, Lisbon, where it served as the community's high school until 1905. The building was then renamed the Lisbon Village Grammar School. It served in that capacity until Lisbon's new elementary school was dedicated in October 1960. The old high school has since been sold to a private landowner. (Ken and Arlene Harris.)

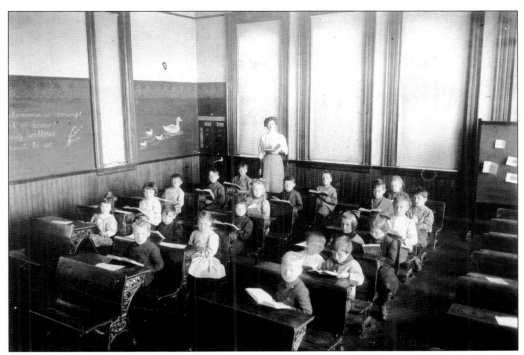

Elizabeth Longley is pictured teaching a lesson to her class at the Common School in Lisbon during the 1901–1902 school year.

State of Maine.

TEACHER'S CERTIFICATE.

It is Hereby Certified That M̲c̲s̲i̲ ̲ ̲*Alice Longley*̲ ̲ ̲ ̲is a person of good *moral character, and having passed an Examination in Reading, Writing, Arithmetic, Geography, History, and other branches usually taught in common schools, is hereby authorized to* teach the ̲ ̲*Farrell*̲ ̲ ̲ ̲School, in the town of Lisbon.

̲ ̲ ̲ ̲ ̲*A. E. Coolidge*̲ ̲ ̲ ̲ ̲Superintendent.

Lisbon, ̲SEP 7 - 1907̲ ̲ ̲ ̲ ̲190

This is a teacher's certificate issued on September 7, 1907, by the State of Maine to Alice Longley, believed to be the sister of Lisbon teacher Elizabeth Longley.

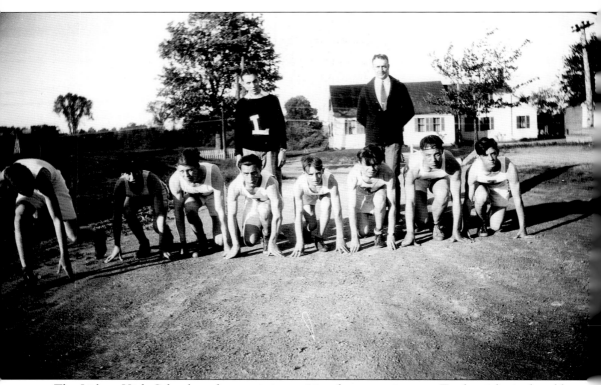

The Lisbon High School track team is in position for a practice run. To the right is the old Lisbon High School. Straight ahead is the Yenko home, and down the road to the left is Millett's field where Cedar Lodge is located. (Linda Gamrat.)

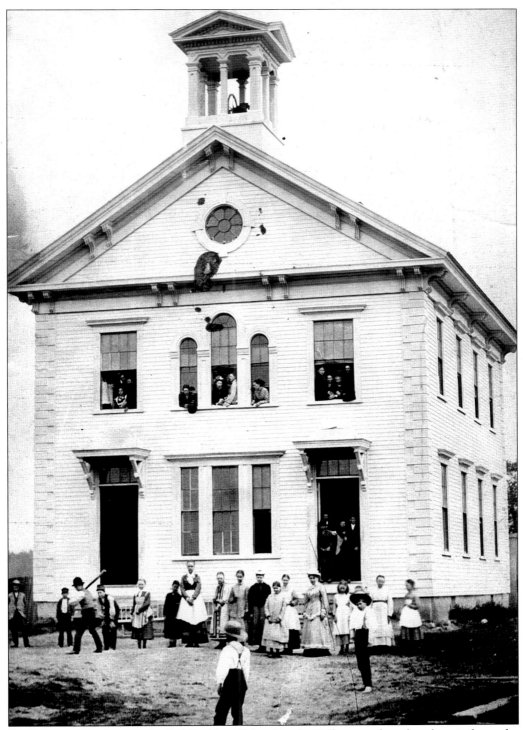

Students and teachers at the Bell Building School in the Falls are gathered at the windows, the doors, and out in the schoolyard to watch the baseball game in action.

LISBON FALLS HIGH SCHOOL

Name of Pupil *Mary Booker* Class, *1926* Curriculum, *Com.*

Report of School Work for School Year 192 *4* 192 *5*

Half Days absent Times tardy

One unit equals 36 weeks work, 5 periods per week. 16 units required for graduation. Music counts 1-4 unit. A rank of 85% is required for certification to college. 70% is the passing mark.

Subjects:	First 6 wks.	Second 6 wks.	Third 6 wks.	Semi-Final Exam.	First Sem. Av.	Fourth 6 wks.	Fifth 6 wks.	Sixth 6 wks.	Final Exam.	Second Sem. Av.	Final Av.
Eng.	A	A	A			A	A	A			
Chemistry	C	A	B			A	A	A			
Algebra	A	A	A			A	A	A			
French	B	A	A			A	A	A			
Dom. Sci.	A	A	A			A	A	A			

H E Bowman. Principal

(See other side)

This is Mary Booker's junior year report card from Lisbon Falls High School from school year 1924–1925. Report cards were issued every six weeks, five times during the school year. With almost straight As every period, she was obviously an excellent student.

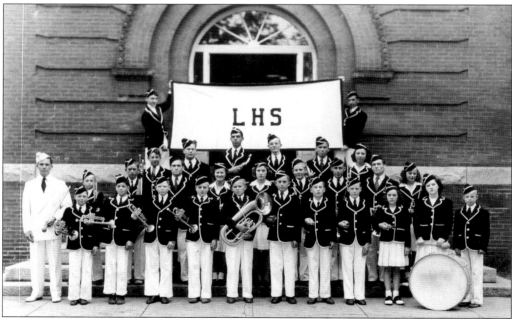

The first Lisbon school band was comprised of high school and elementary school students. Uniforms, including jackets and caps, were made by the mothers of the band members, using donated cloth from the Worumbo Mill. On the left, in white, is the drum major Robert Lawrence. (Merton Richer.)

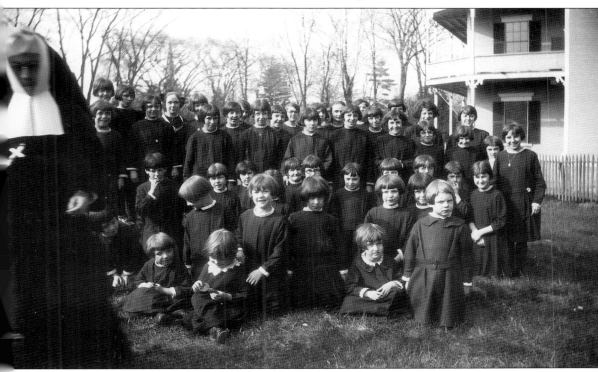

The uniformed children of St. Bernadette's Parochial School on Main Street in Lisbon pose for a picture outside on the lawn. In 1930, this school was established from the former Elder Hotel. Catholic children in grades one through eight received their elementary educations there until 1969. (Linda Gamrat.)

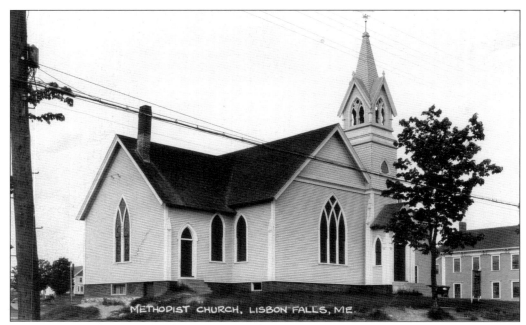

METHODIST CHURCH, LISBON FALLS, ME.

Lisbon United Methodist Church was dedicated in 1889 at its present home on the corner of Berry and School Streets in Lisbon Falls. Over the years, the church has partnered with Marion T. Morse School on a number of initiatives and has merged with the Lisbon Village Methodist Church, proving to be a true community church.

St. Matthew's Episcopal Church, a modest yet beautiful landmark, is pictured at its first location on Main Street in Lisbon Falls. (Lisbon Historical Society.)

The first Roman Catholic congregation in Lisbon was established in 1885. The architecturally pleasing St. Anne's Catholic Church on Main Street in Lisbon Village was opened on Easter Sunday in 1886.

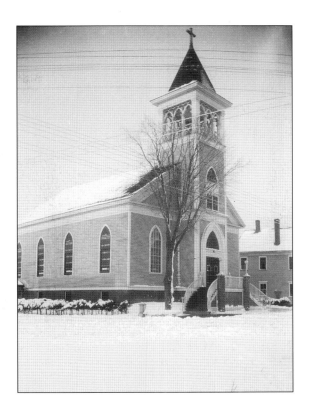

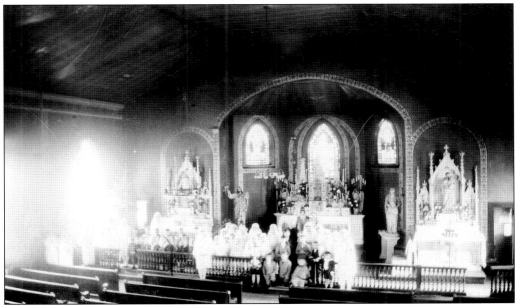

This is a rare photograph of a ceremony inside the beautifully ornate St. Anne's Church in Lisbon around 1900. (Linda Gamrat.)

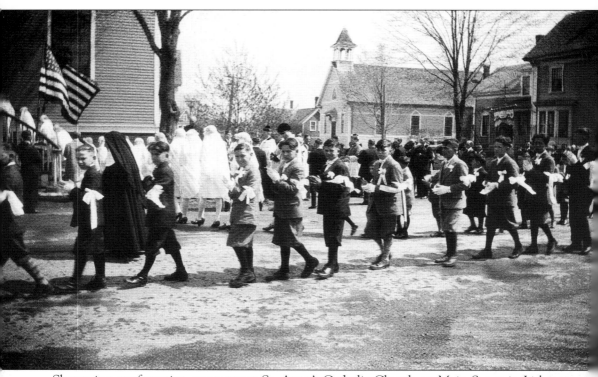

Shown is a confirmation ceremony at St. Anne's Catholic Church on Main Street in Lisbon. (Linda Gamrat.)

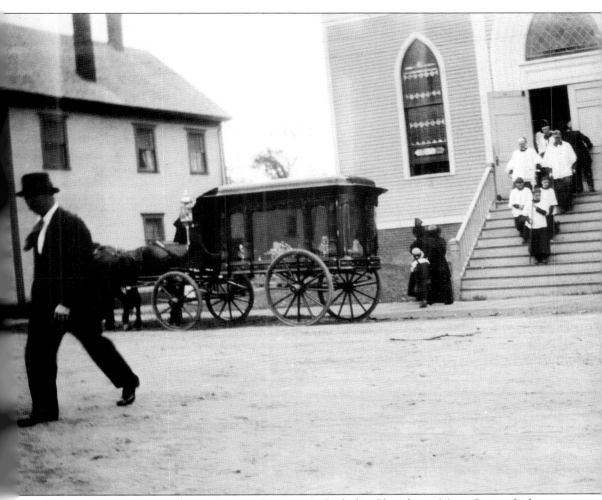

A funeral procession is shown leaving St. Anne's Catholic Church on Main Street, Lisbon. Pictured is a horse-drawn hearse of exquisite detail. (Linda Gamrat.)

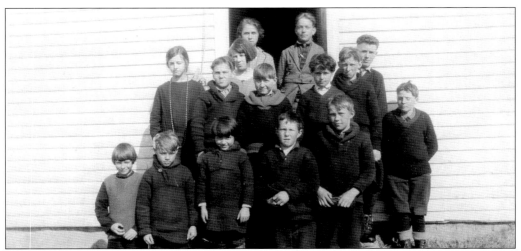

Students at Ridge School House, Lisbon Falls, pose with their young teacher, Ellen Margitan, standing on the top left in the doorway, for this c. 1910 image. Never married, Margitan devoted her life to teaching. Finishing her career at Lisbon High School, where she taught business classes, she was a respected member of the faculty. (Lisbon Historical Society.)

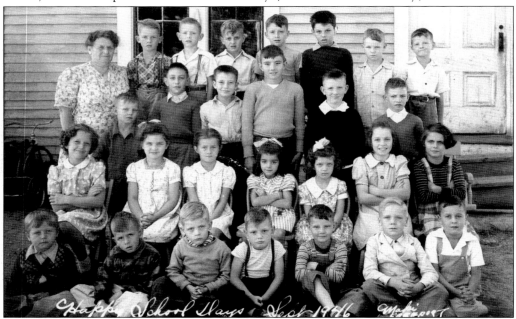

This 1946 photograph of students at Lisbon Center School pictured a young Bill Dunlop, who grew up to become an adventurer and solo sailor and was lost at sea during his 1984 voyage. Dunlop is the first little boy in the bottom row. This others pictured, from left to right, are as follows: (first row) Larry Duval (next to Dunlop), David Schultz, Wayne Uash, Harley Warren, Everett Owens, and Donald ?; (second row) Barbara Hall, Joan Adamowitcz, Phyllis Atwood, Phyllis Richards, Shanon Breton, Pattie Owens, and Charlotte Schultz; (third row) Kaile Warren, Donald Duval, Richard Cross, Henry Kenney, Lloyd Gray, and Bruce Duval; (fourth row) teacher Mamie Beal, Stephen Ham, Lee Blanchard, Larry LaChance, Thurl Hinkley, Bill Brann, Carroll Warren, and David Micah. (Lisbon Historical Society.)

Seven

THE FACES OF LISBON

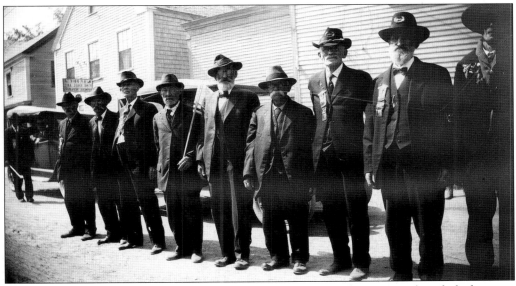

While all of the men and women in these poignant photographs are not identified, these are the faces of a community's legacy. These men, women, and children shaped a community by hard work, sacrifice, commitment, and humor. They are the keepers of old-world traditions, and the pioneers in a new land. Of all the town's outstanding qualities, it is the people of the town that have secured Lisbon's place in history. These citizens were frugal, and they were generous. They worked hard, they played hard, and they loved well. Lisbon's people speak a variety of old tongues and keep stories alive by their faith and their memories. They were not perfect, but they were great. Every face in these photographs has a place in Lisbon's history. They represent the hearts and souls of Lisbon, of Maine, and of America.

Pictured here at the seashore, Charles Frederick Mann became a household name in 1891 when he took on the job of managing editor of the Enterprise Publishing Company of Lisbon Falls, producing the *Enterprise* newspaper. A prominent businessman, his professional memberships included the Knights of Pythias, Red Men, Pilgrim Fathers, Maccabees, and county, state, and national Granges. (Lisbon Historical Society.)

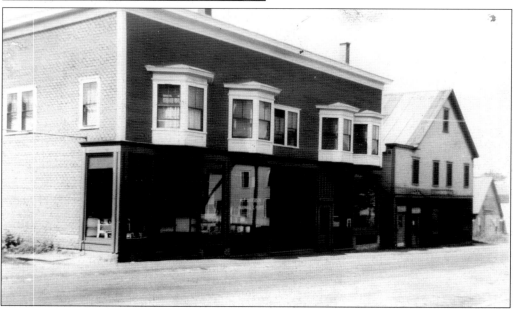

The entire first floor of the 50-by-75-foot Enterprise building on Union Street in Lisbon Falls was occupied by the Enterprise Publishing Company under the management of Charles Mann. The upper floor was reserved as a society hall. Most recently, the Enterprise was managed by Norm Fournier, who was also one of the founders of the Lisbon Historical Society. (Lisbon Historical Society.)

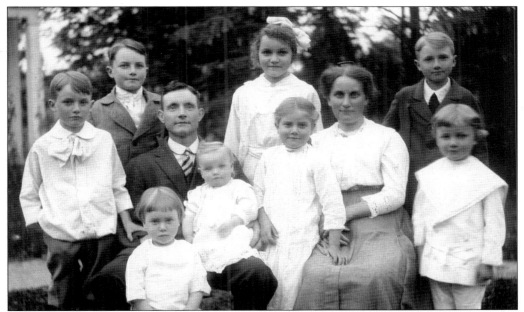

Large families were the norm in the early-1900 Lisbon community, helping to cement traditions, customs, and values that were passed on to future generations. Representative of close-knit relatives was the Clarence Parker family. Pictured here are the following: (first row) Arthur (standing) and Florence (in lap); (second row) Lemuel, Clarence (father), Ruth, Mary (mother), and Frank; (third row) Philip, Esther, and Andrew. Family members unborn at the time of the picture included Bessie, Herbert, and Walter. (Lisbon Historical Society.)

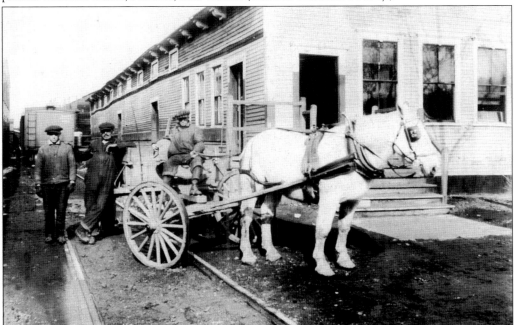

Roy Goodwin's Driving Team, part of the Pejepscot Paper Mill yard crew, is shown resting on the tracks with a loaded wagon in Lisbon Falls.

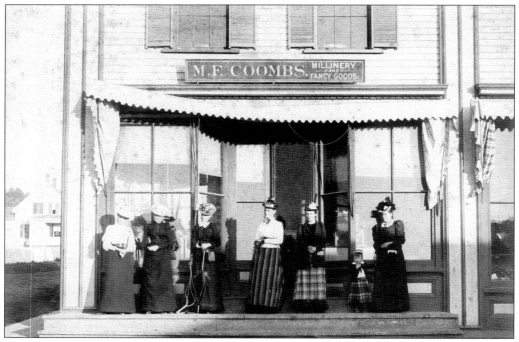

Mary Frances Coombs, daughter of John Henry Coombs, was a longtime proprietor of a popular millinery and fancy goods shop.

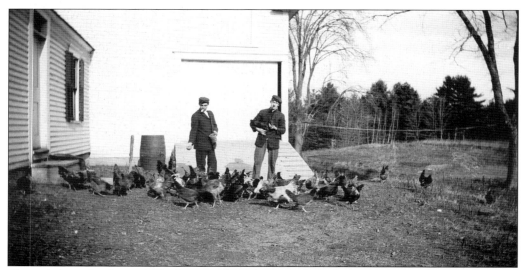

This is believed to be an 1873 photograph of the Coombs home at the beginning of Ferry Road in Lisbon.

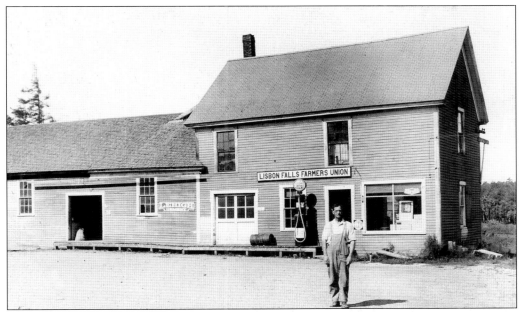

Alzo Merrill is standing in front of the Lisbon Falls Farmers' Union building in 1903. (Ken and Arlene Harris.)

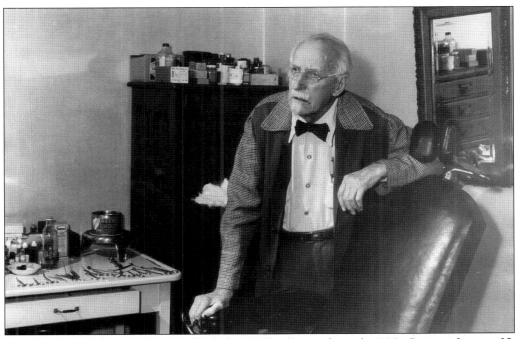

Dr. Albert W. Plummer is shown in his Lisbon Falls office in the early 1900s. Born on January 25, 1869, in Lisbon Falls, Plummer was educated in town, received his doctorate from Maine Medical School in 1894, and practiced in Oakland, Maine, for a dozen years. He returned to Lisbon Falls, where he would remain as beloved doctor, active citizen, and friend to all. (Lisbon Historical Society.)

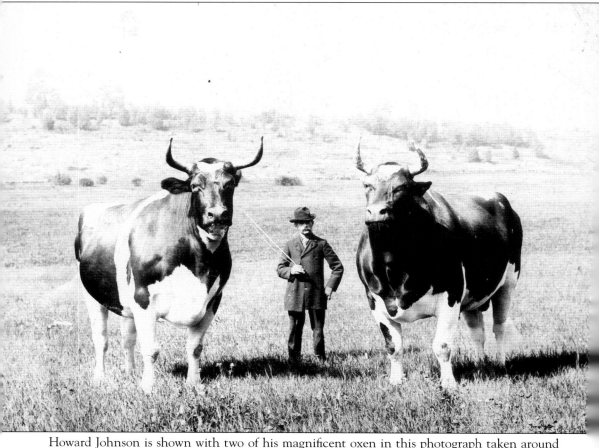

Howard Johnson is shown with two of his magnificent oxen in this photograph taken around 1890. The incredible strength of these animals was used to transport lumber for the Androscoggin Water Power Company. (George Huston.)

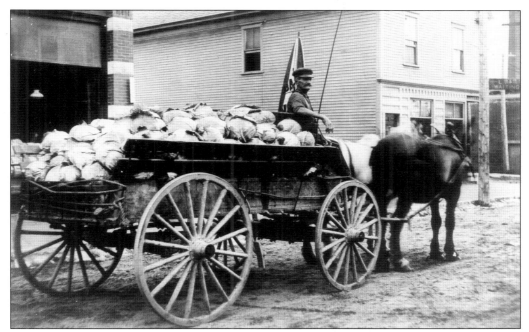

Howard Bragdon, one of Lisbon's many traveling sellers, is pictured on Main Street, Lisbon Falls, with a full wagonload of fresh cabbage. The horse-and-wagon teams were invaluable to vendors of the early 1900s. (Lisbon Historical Society.)

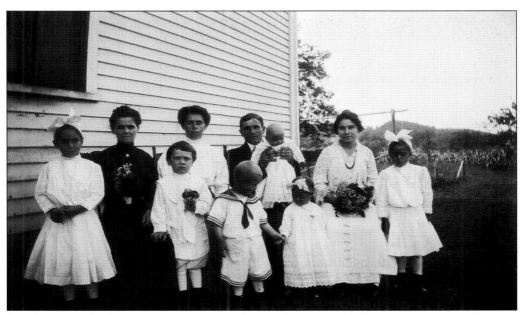

Farming was a Maine tradition and a true family effort in early-20th-century Lisbon. Families with upwards of a dozen children worked hard throughout the week, saving Sunday as a day of rest.

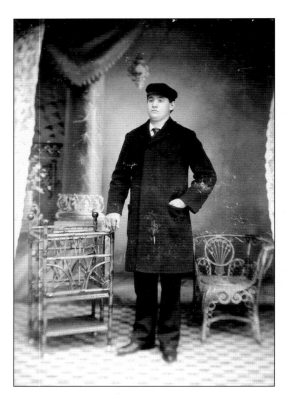

Canadian Solomon Bernier immigrated to the United States in 1892 at the age of 12. He moved from Vermont to Lisbon, Maine, where he farmed as an adult.

This is Bernier's declaration of intention paper, filed with the U.S. Department of Labor's Naturalization Service on September 11, 1918.

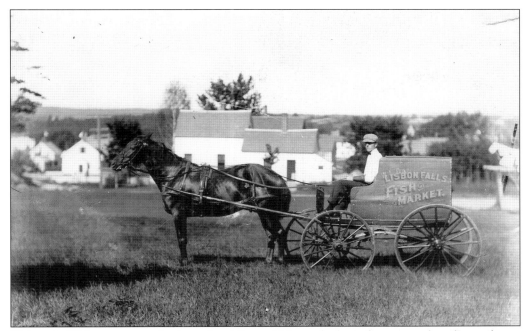

This early-20th-century seafood vendor delivered his catch throughout town by a horse-drawn wagon for the Lisbon Falls Fish Market. Blocks of ice covered with sawdust kept the fish fresh and cold in the "horse-and-buggy days." (George Huston.)

Four unidentified men pose for a holiday picture.

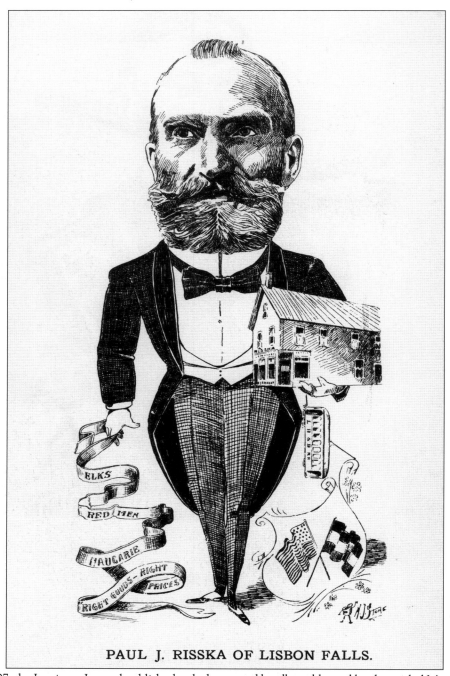

PAUL J. RISSKA OF LISBON FALLS.

In 1907, the Lewiston Journal published a cloth-covered hardboard-bound book entitled *Men of the Hour as Told in Cartoon and Verse*. The book was 13 inches by 7 inches and was bound by ties made of material similar to the cover. Each page of the book was dedicated to a well-known person in a particular area. A likeness of the person was in a pen-and-ink-type look, and under the caricature was a humorous poem describing the character. The entries were arranged alphabetically by hometown. Lisbon Falls's entry was of Paul J. Risska, businessman and active citizen.

Pictured are two men standing on a rock in the Sabattus River just in front of the floodgates, down from the falls, by the Farwell Mill. The picture is from around 1900. (Linda Gamrat.)

Shown here are children playing outside with a wooden wagon, most likely one of the first types made by Radio Flyer. It is interesting to note that even children wore the big hats that were so popular during the early 1900s.

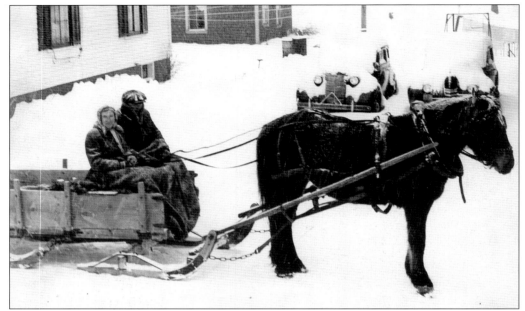

Stanley and Mary Tarr greeted neighbors as they sold ice, butter, milk, cream, and eggs harvested from their own farm on Summer Street in Lisbon Falls. The Tarrs delivered door-to-door every day, with the help of their horse, Dolly. Children enjoyed feeding sugar cubes to Dolly as she made her way through town, pulling either a sleigh or wagon. (Lisbon Historical Society.)

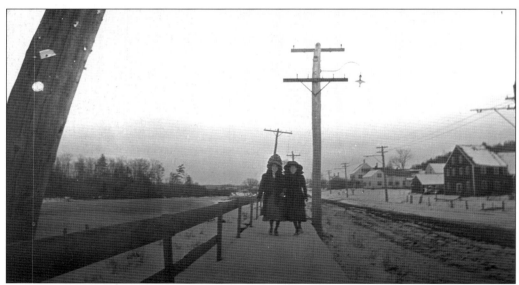

This is a photograph of two ladies with very large hats strolling down the wooden boardwalk along the Sabattus River near Peppermint Corner in Lisbon. It is said that the location's name was taken from a peppermint candy shop located in the area. (Linda Gamrat.)

114

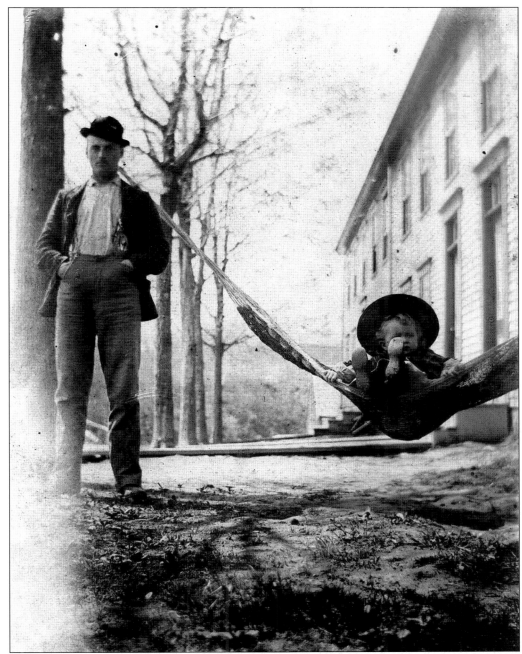

Frank E. Burrill, an employee of the Farnsworth Mill, takes time out while an adorable child enjoys the hammock. Both are most likely residents of the Farnsworth Boarding Home, pictured in the background. The apartments, located in Lisbon Center, were sponsored by the mill, and were offered as rentals to Farnsworth Mill employees and their families. This is image is from about 1910.

A beautiful image of a typical early-20th-century farming family in Lisbon shows a house and barn, a horse for transportation and for work, and a cat under the porch by the horse. (Linda Gamrat.)

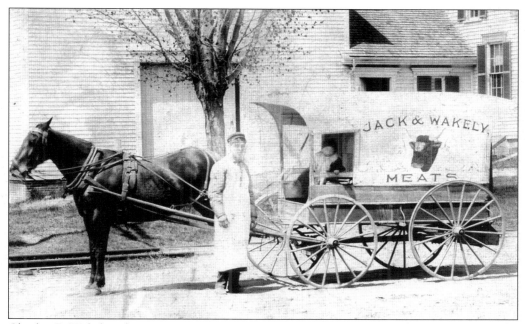

Charles F. Wakely, who was co-owner of a grocery store on Main Street, Lisbon Falls, with Louis Jack, poses at the front of his delivery wagon in 1901. With his son, also Charles, seated in the wagon, Wakely loaded meats, milk, cheese, and other groceries into the wagon, making deliveries throughout town. (Harrison Wakely.)

Servicemen Robert Leblonde, in the navy, and Paul Leblonde, a marine, are home on leave in the 1920s. They are pictured here in the backyard of their beloved grandmother, Marie Berube of Lisbon. The story is told that at one point in their military service, they met unexpectedly overseas while on duty. (Linda Gamrat.)

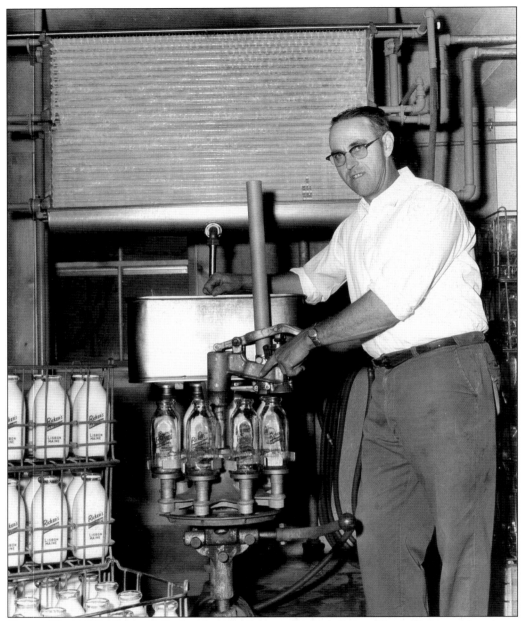

Here is Howard Ricker with his bottling machine at Ricker's Dairy. The milk is running down over the cooling coils into the vat and then into the bottles for capping. Howard's son, Merton, remembers that when he was a kid there were five dairy operations on Ridge Road, Lisbon, where Ricker's Dairy was located. There was also the Levi Ross farm in West Lisbon and other dairies in Durham. They each raised their own cows, processed the milk, and delivered it door-to-door to customers daily. (Merton Ricker.)

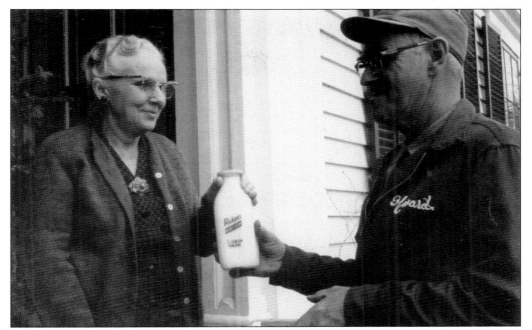

Howard Ricker is shown delivering milk to Iva Millett of Lisbon. Ricker began his dairy route as a teenager, and Millett was his very first customer. She remained a loyal and valued customer until the day he retired his business. (Merton Ricker.)

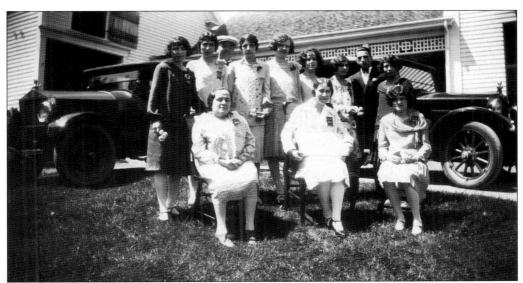

Upon enlargement of this image, the sign being held by the woman seated in the middle read, "Club 1928 Ala Mode." This sign, along with the matching ribbons that all the women are wearing, leads one to believe it was an organized group, perhaps a cooking club, a book club, or something even more intriguing. It would be great to hear from folks who have first-hand knowledge of this group.

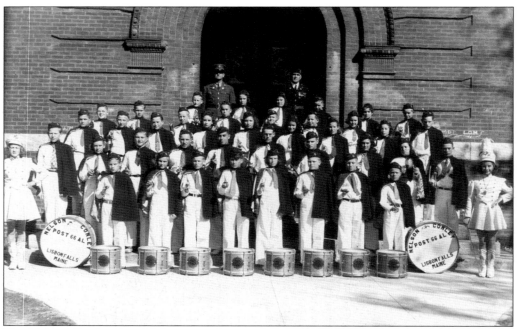

The Nelson Conley Post 66 American Legion Drum Corps of 1937–1939 played at most town functions, including parades and ceremonies. Lewis Barrett, the band's music instructor, is in the top row beside Edward Butler, the marching instructor.

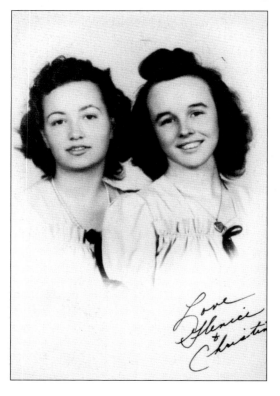

Cousins and best friends, Glenice Wheeler and Christine Webber grew up together in the 1920s and 1930s enjoying many a Lisbon Falls adventure.

Out for a real joy ride, these local folks are making the most of carpooling. Taken on the hill in Lisbon Center, the photograph shows the Farnsworth Mill and water tower in the background. Theophile Bernier, married to Anna Mackovjak, is in the bib overalls. (Lisbon Historical Society/Madeline Junkins.)

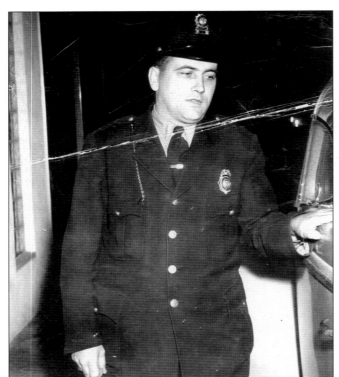

Albert "Bud" Junkins is shown here proudly wearing the uniform of a Lisbon police officer. Having been honored as a World War II veteran, he served as a well-respected constable, police officer, and finally, police chief for the community for a quarter of a century.

Shown together are Esther and Fernand Lavoie, lifetime residents of Lisbon Falls. Married for 63 years, the couple was well known for attending dances every Saturday night throughout their marriage. Fire chief for several years in Lisbon Falls, as well as bus driver and custodian for the Lisbon School System, Fernand continued to participate with his friends in a bowling league and enjoyed golfing well into his 90s.

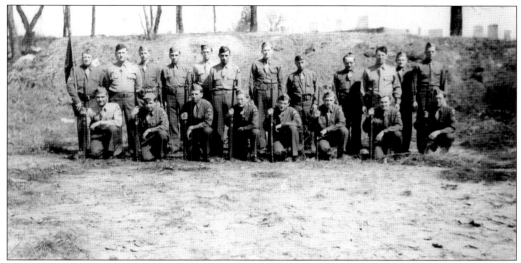

This is a photograph of 20 townspeople, all sworn in as members of the Lisbon Falls Guard Reserve on October 4, 1942. Their duty was to serve the state of Maine during the war as a reserve company in order to guard and protect the town of Lisbon in case of invasion by parachute troops or other dangers. Pictured from left to right are (first row) guardsmen ? Nolan, ? Jordan, ? Doboga, ? Berlanger, two unidentified men, ? Gensure, and ? Anicetti; (second row) reservists ? Goddard, ? Williams, ? Curtis, unknown, ? Hale, ? Bernier, unidentified, ? Lauze, ? Beal, ? Morin, unidentified, and ? Lemke. (Lisbon Historical Society.)

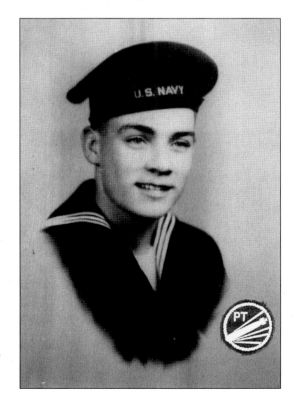

Thomas "Scotty" Huston, a decorated World War II veteran, is an invaluable member of the Lisbon Historical Society. Huston was on the famous PT 109 boat for a while, where he had President Kennedy as an instructor for a very short time.

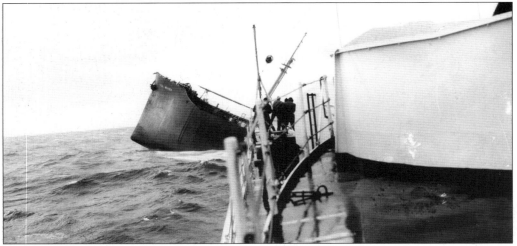

On February 18, 1952, his 20th birthday, Paul R. Black of the U.S. Coast Guard, and a resident of Lisbon, was able to give the gift of life in a way that few people will ever experience. Responding to an SOS from two sinking merchant tankers off the coast of Cape Cod, six coast guard vessels, including the U.S. Coast Guard cutter *Yakutat*, began "a rescue that involved lifesaving operations unique in Coast Guard history," praised CG Vice Adm. Merlin O'Neill. The tankers were 40 miles apart, in the midst of a northeaster, bearing 70-knot winds and 60-foot seas. Both tankers were broken in half and sinking with their crews aboard. Half-frozen men were struggling to survive atop the broken hulks of the two crippled ships. The stranded sailors were being plucked to their death by monster waves in front of the coastguardsmen's eyes. For two days, the exhausted but determined coast guard crew launched rescue missions back and forth to the tankers. Engineman Black "displayed outstanding seamanship" as engineer of the motor surfboat that was also damaged and in danger of sinking as he and another guardsman pulled survivors from the boat and the raging sea. "The situation called for raw courage and skill in the highest order. . . Black's exceptional courage, professional skill and unwavering devotion to duty were in keeping with the highest traditions of the United States Coast Guard," cited the secretary of treasury as he pinned the Silver Lifesaving Medals for heroic action onto Paul Black's uniform during a ceremony in Washington, D.C.

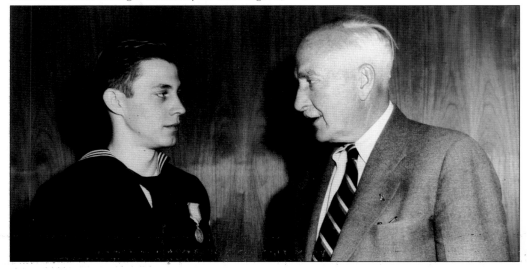

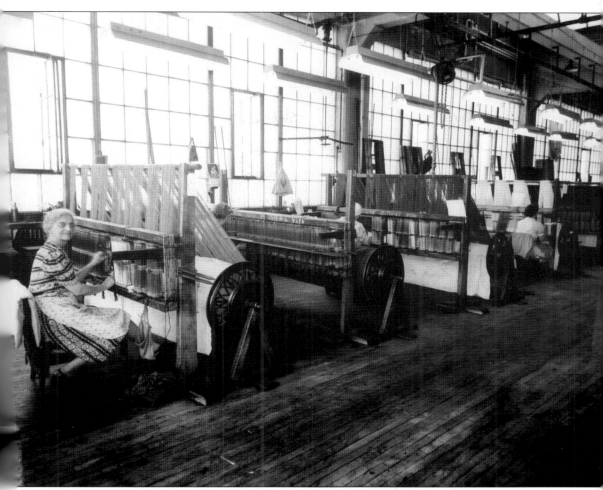

Mary Galgovitch was one of many Lisbon residents who worked her entire life producing fine fabrics at the Worumbo Mill. Here is the weaving room where Mary worked for 56 years, from age 14 to 70. (Lisbon Historical Society.)

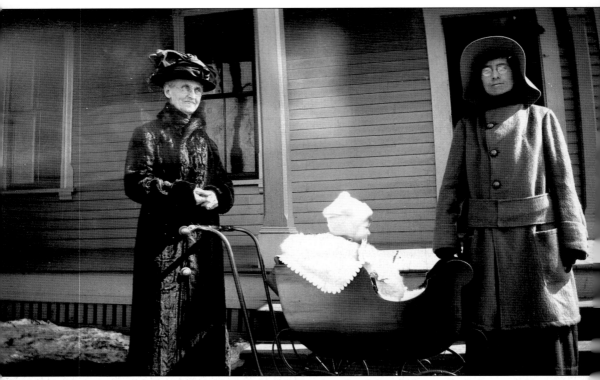

Although these folks are not identified, the photograph of the clothing, the baby carriage, and carriage skirt are priceless. This is early-1900s Lisbon.

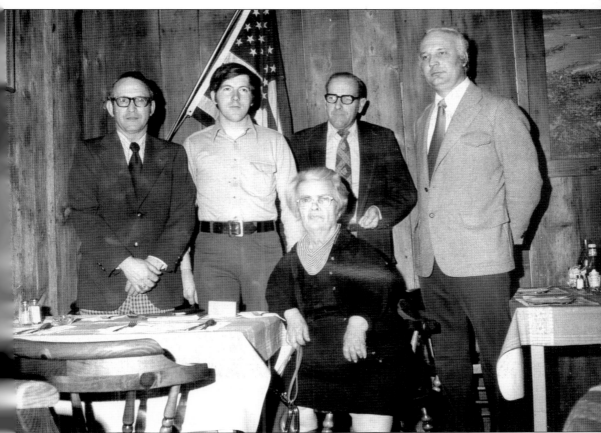

This picture shows five very active advocates for the town of Lisbon. From left to right are Bill Barr (presently working hard to preserve the town history at the Lisbon Historical Society), David Bowie, John Jalbert, Richard Laroche, and Mary Dumas.

ACROSS AMERICA, PEOPLE ARE DISCOVERING SOMETHING WONDERFUL. *THEIR HERITAGE.*

Arcadia Publishing is the leading local history publisher in the United States. With more than 3,000 titles in print and hundreds of new titles released every year, Arcadia has extensive specialized experience chronicling the history of communities and celebrating America's hidden stories, bringing to life the people, places, and events from the past. To discover the history of other communities across the nation, please visit:

www.arcadiapublishing.com

Customized search tools allow you to find regional history books about the town where you grew up, the cities where your friends and family live, the town where your parents met, or even that retirement spot you've been dreaming about.